IMAGES
of America

SAN DIEGO'S
FISHING INDUSTRY

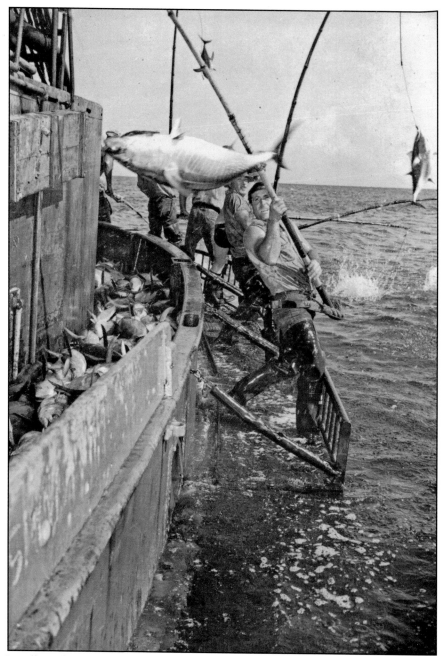

Sam Crivello is shown aboard the *Sun Harbor* around 1944. The image depicts the tremendous strength necessary to haul in a tuna while pole fishing and highlights the typical conditions men would face at sea. (Courtesy of the Crivello family.)

ON THE COVER: Sicilian fishermen pose on the *Anna* around 1935 in San Diego Bay. The owner of the boat was Salvatore Piranio. Pictured from left to right are unidentified, Pete Piranio, Girolamo Balistrieri, Giuseppe Sardina, Frank Crivello, unidentified, and Frank Piranio (in back). (Courtesy of Rosalie Balistrieri Lo Grande.)

IMAGES *of America*

SAN DIEGO'S FISHING INDUSTRY

Kimber M. Quinney, Thomas J. Cesarini,
and the Italian Historical Society
of San Diego

ARCADIA
PUBLISHING

Published by Arcadia Publishing
Charleston, South Carolina

Printed in the United States of America

Library of Congress Catalog Card Number: 2008933029

For all general information contact Arcadia Publishing at:
Telephone 843-853-2070
Fax 843-853-0044
E-mail sales@arcadiapublishing.com
For customer service and orders:
Toll-Free 1-888-313-2665

Visit us on the Internet at www.arcadiapublishing.com

We humbly dedicate this volume to all the immigrants and their families
who toiled in San Diego's fishing industry to create not only a livelihood,
but also a way of life and a lasting legacy.
We also wish to thank our families for their support and patience
throughout this worthy endeavor.

CONTENTS

ACKNOWLEDGMENTS

We wish to express our heartfelt gratitude to all the families and contributors whose images, stories, generosity, and community spirit directly made this book possible. We are grateful to the following families: Alioto, Balistreri, Brunetto, Carini, Castagnola, Corona, Cresci, Crivello, D'Amato, Guidi, Kamfonik, Lococo, Massa, Navarra, Piraino, Stagnaro, Tarantino, Vattuone, Zolezzi, and Zottolo families. And we also enthusiastically express our thanks to the following individuals for their contributions to this collection: Catherine Alioto, Andrew Asaro, Rosemarie Balistreri, Anthony Bregante, James Bregante, Richard Bregante, John Brunetto, John Canepa, Joe Carini, Andy and Rosella Castagnola, Joseph Castagnola Jr., Mary Louise Castagnola, Sal Corona, Tom Cresci, Salvatore and Angela Crivello, Frank D'Amato, Margaret Tarantino Faber, Mario Ghio, Louis Guidi, Maria Vattuone Iraci, Mary Kamfonik, John Lococo, Rosalie Lo Grande, Anthony Madruga, Seth Mallios, John Mangiapane, Laurie Massa Jr., Ed Pecoraro, Larry Piraino, Carolann Vattuone Pollan, Nigel Quinney, Marie Sohl, Andrew Stagnaro, Anthony Tarantino, Bernadette Tarantino, Joe Tarantino, Clara Stagnaro Vattuone, Stephanie Zolezzi, Vito Zottolo, Donna Calhoun and Therese Garces of the Portuguese Historical Center of San Diego, Linda Canada of the Japanese American Historical Society of San Diego, Kevin Sheehan and Maggie Wharton of the Maritime Museum of San Diego, and the owners of American Tuna, Inc.

Special recognition and gratitude must go to the following individuals: James Bregante, for his indispensable help in identifying community resources to include in this volume, as well as for his vast knowledge of the Italian community and fishing industry; Sal Corona, who also helped to bring this project to the masses in the Italian community, and also for his sharp memory, which proved invaluable in our effort; Donna Calhoun, for opening up the Portuguese Historical Center archives to us and for sharing the rich history of the Portuguese community; and Debbie Seracini, our patient editor, whose guidance remains very much appreciated.

This volume is a result of your efforts and support—we thank you all.

For more information on San Diego's Italian community, or to contribute materials to the Italian Archives of San Diego, please visit italianhistory.org or call (888) 485-4825.

INTRODUCTION

In 2004, workmen repairing the Hardy Tower at the San Diego State University uncovered two murals that had been hidden behind a drop ceiling since the mid-1950s. One of the two murals consisted of panels painted by George Sorenson in 1936 as part of the New Deal reforms. Sorenson's 6-foot-by-30-foot work is entitled *San Diego Industry* and portrays the various stages of the local tuna-fishing industry and the different groups of people involved at each stage: fishermen, dock workers, canning women, merchants, and others.

For several reasons, the discovery of the mural provides a perfect point of departure for this book. In the first place, the unveiling and restoration of *San Diego Industry* underscores a growing sense of urgency to rediscover and protect the history of "America's Finest City" before memories and photographs fade, old neighborhoods are swept away by new developments, and that history is lost forever. Second, just as George Sorenson aimed to do, this book celebrates the centrality of the fishing industry to San Diego's economic and cultural growth. And third, like Sorenson's expansive portrait, this book captures the remarkable breadth of activity in the fishing industry and the equally diverse characters of the people who built that industry.

Beginning in the late 19th century, fishing tempted a wide variety of immigrant families to make San Diego their home. The first chapter in this book, "Exploring New Waters: Migrants Make an Industry," provides a brief history of fishing in San Diego and highlights the innumerable contributions made by Chinese, Japanese, Italian, Portuguese, Dalmatian, Mexican, and other immigrants who defined—and whose lives were defined by—fishing. In this chapter, we echo Sorenson's portrayal of the fishing industry by celebrating the wide diversity of fishing communities who truly defined the industry.

The photographs in chapter two, "A Catch-All Industry: Fishing and the Community," capture the communal experience of fishing: mothers and children gathered on the dock to see the boats head out to sea; families and friends donning their Sunday best to join the priest in christening and launching a new boat; and entire extended families sailing to Coronado for a family picnic. As the photographs reveal, San Diego's fishing boats were much more than boats for fishing; they literally and figuratively kept fishing families afloat, sustaining entire neighborhoods and bringing San Diegans together in numerous ways.

As shown in chapter three, "Bait and Tackle: Tools of the Trade," San Diego's fishing industry was wonderfully innovative thanks to the traditional techniques that the immigrants brought with them from their homelands. This inventiveness was most visible in the wide range of fishing boats that characterized the industry; the boats typify the diversity of the people who designed them, built them, blessed them, launched them, and fished on them. The images in chapter three represent both individual and corporate boatbuilders, many of whom gained national fame for their mastery of boatbuilding in San Diego. The immigrants brought other tools, too, such as unusual poles, hooks, bait, and nets, as well as a wealth of expertise and a wide range of techniques in critical areas such as identifying the best fishing grounds on any given day and avoiding the netting of unwanted species.

Like Sorenson's mural, this book surveys everyone with a role to play in the fishing industry—not just fishermen, but also dock loaders, cannery workers, retail merchants, restaurant owners, boatbuilders, and sports fishermen. The mosaic of photographs in chapter four, "Coming Ashore: Life on the Docks" illustrates the broad variety of jobs that were as important to the success of the industry as fishing was. The images reflect the way in which the industry thrived and expanded, becoming San Diego's primary industry and propelling the city's growth between the 1920s and the 1940s.

The final chapter, "Looking Downstream: End of an Era," identifies the litany of challenges to San Diego's fishing industry, and to the tuna industry in particular. The chapter traces the impact of the Great Depression in the 1930s; economic competition from Japan in the 1950s; and the troubled years of the 1970s, when environmental concerns brought critical attention to some fishing practices. Chapter five identifies the economic challenges faced by fishing families in San Diego in the last decades of the 20th century and shows how local, state, and national government policies and international competition and restrictions affected their livelihoods. And yet, in spite of the economic ups and downs, the final chapter also celebrates the fact that thousands of San Diegan fishermen and their families proudly continue to make fishing a "San Diego Industry."

Our aim in this book is to capture the historical evolution of the fishing industry in San Diego. We recognize and celebrate the diverse ethnic communities that made the industry what it was—the engine that drove San Diego's economy and shaped its culture. The greatest challenge for us has been to reflect the entire breadth of that diversity. In the case of some ethnic groups, few photographs seem to survive, and many of those that do are closely guarded by their institutional custodians, making it difficult for us to do justice to that group's contribution to the story told in this book. Happily, however, we have benefited from the generosity of numerous families and some organizations keen to share their prized photographs; the richness of this book reflects the richness of each family's history and the combined wealth of the city's fishing legacy. Limitations of space meant that we could use only a fraction of the trove of fascinating photographs made available to us, and we extend our apologies to those families whose photographs were not included in the final publication. We hope, however, that all San Diegans will enjoy the inspiring tale told in this book of how hardship and perseverance, diversity and innovation, commitment and cooperation built not only an industry, but also a city.

One

Exploring New Waters
Migrants Make an Industry

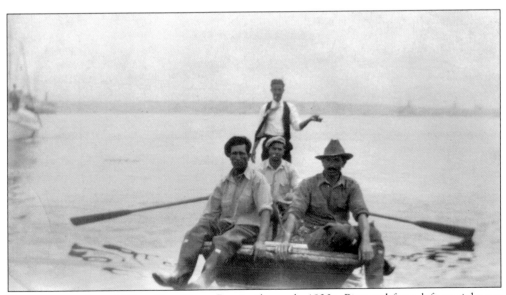

Four men row in a skiff on San Diego Bay in the early 1930s. Pictured from left to right are Antonino Tarantino, Giovanni Tarantino, Pietro Tarantino, and unidentified (in back). (Courtesy of the Tarantino family.)

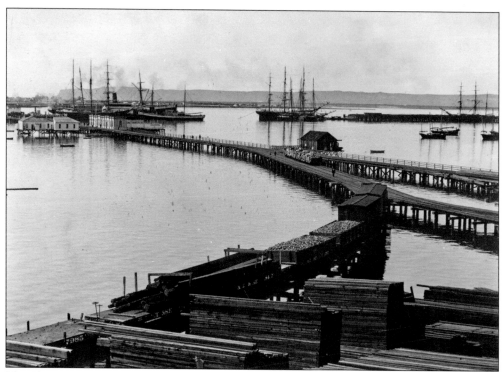

The Chinese were among the first pioneers in the fishing industry. They came down from the Sierra Nevada gold mines to pursue their livelihoods without the discrimination they had experienced in the mining regions, and many did so successfully as fishermen. This c. 1890 image captures Chinese junks (far right) as they sit in the San Diego Bay, framed by what was then known as Pacific Coast Steamship Company Wharf at the foot of Fifth Street. (Courtesy of Maritime Museum of San Diego.)

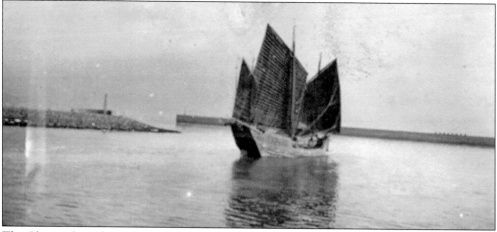

The Chinese brought traditional fishing techniques from the old country, relying on distinctive fishing boats, namely junks and flat-bottomed sampans. The fishermen used hook-and-line techniques to catch redfish, barracuda, and shark, much of which was preserved and exported to merchants in San Francisco and, later, to China. The dried fish export market out of San Diego by the Chinese fishermen was well established by 1872. (Courtesy of Maritime Museum of San Diego.)

At the height of the Chinese fishing industry in 1886, there were 18 junks based at San Diego, 12 of which were harvesting abalone. The most remunerative export for the Chinese fishermen was black abalone. By 1880, the San Diego abalone fishery was producing 700 tons annually, primarily for export to China. The abalone shell was valued by Californians, who used it for jewelry. (Courtesy of Maritime Museum of San Diego.)

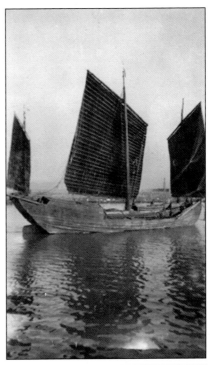

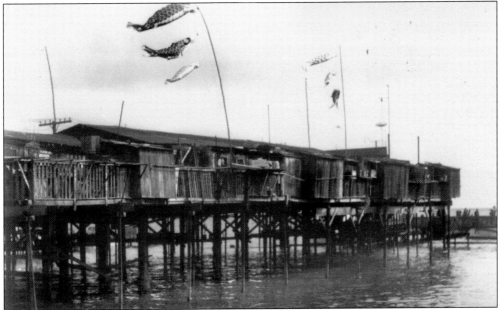

Life at Fish Camp was simple but dangerous. Holes in the wood floors allowed sewage and garbage to fall directly into the bay. More than one child died after falling through these holes. Japanese customs observed at Fish Camp included flying carp flags in celebration of Boys Day and pounding mochi, a special rice used in New Year's celebrations. The camps disappeared forever when the United States became involved in World War II and Japanese nationals and Japanese Americans were moved into internment camps. (Courtesy of Japanese American Historical Society of San Diego.)

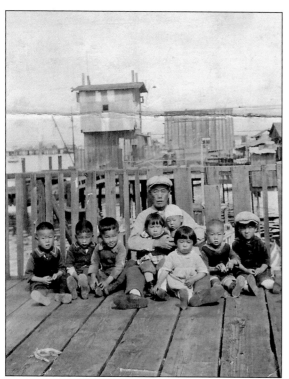

Pictured at left is Tokichi Namiki with children from families living in Fish Camp behind the Van Camp Cannery in 1926. The company built simple housing for fishermen and their families on wooden wharfs extending over San Diego Bay. Other fish camps were located farther north along the bay. One was named Hokkaido after the northernmost island in Japan. (Courtesy of Japanese American Historical Society of San Diego.)

In early 1920, Japanese fishing entrepreneur Kondo Masaharu sailed back to San Diego with 70 fishermen from the Japanese province of Yokohama aboard the three-masted, 200-ton schooner *Toni Maru,* pictured below around 1918. The voyage across the Pacific Ocean purportedly took 35 days. (Courtesy of Maritime Museum of San Diego.)

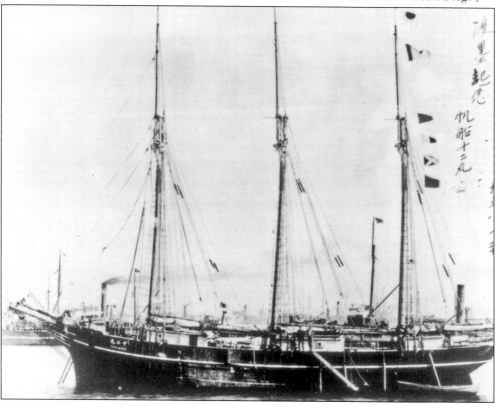

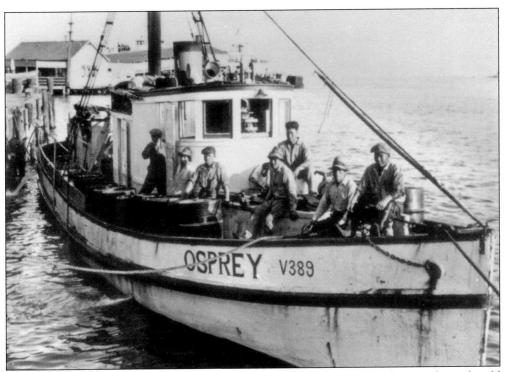

A Japanese fishing boat, the *Osprey*, is shown with crew in this c. 1935 photograph on the old Santa Fe Wharf in San Diego. The *Osprey* was owned and operated by the Taiyo Sangyo Gaisha (Southern Commercial Company), a Japanese-owned cannery located at Turtle Bay in Baja, California. In 1934, the *Osprey* was at the center of a fishing-rights controversy when a superior court judge in San Diego ruled that a California law forbidding Japanese-born fishermen from bringing fish caught in Mexico into the United States was unconstitutional. (Courtesy of Maritime Museum of San Diego.)

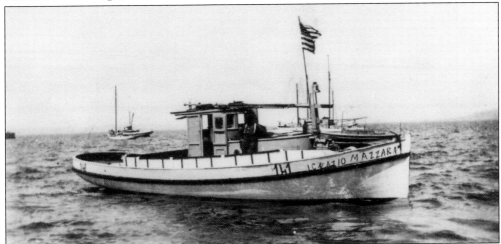

In the early 1900s, Italian immigrants began to make their way in large numbers to San Diego as skilled fishermen. Andrea Asaro's fishing boat, the *Ignazio Mazzara*, cuts through San Diego Bay in the 1920s. The boat was named after Andrea's father, Ignazio, who hailed from the Sicilian town of Mazzara del Vallo, from where many Italian fishermen came. (Courtesy of Andrew Asaro.)

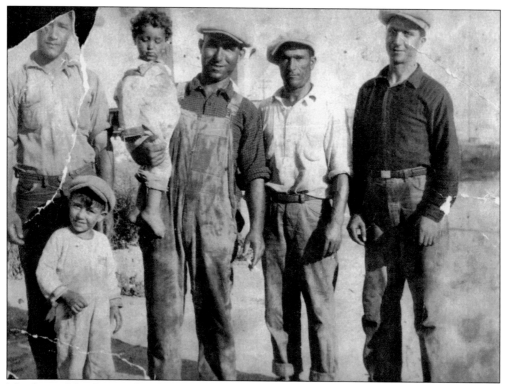

Members of the Corona family and crew of the bait boat *Garibaldi* are pictured around 1927 at the house that is still standing and owned by the family at Kettner and Fir Streets in Little Italy. Giuseppe Corona holds his son, Salvatore Corona; his other son, Donald, is standing in front. (Courtesy of Sal Corona.)

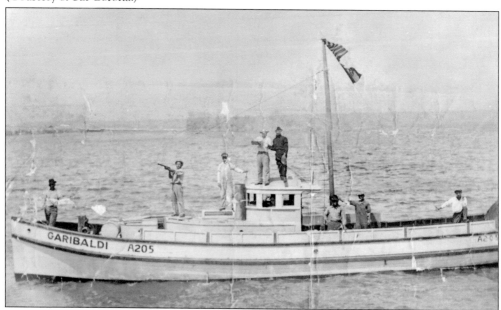

The *Garibaldi*, Giuseppe Corona's first boat, leaves San Diego Bay for a day of fishing around 1927. He is pictured holding the rifle while the crew looks onshore. (Courtesy of Sal Corona.)

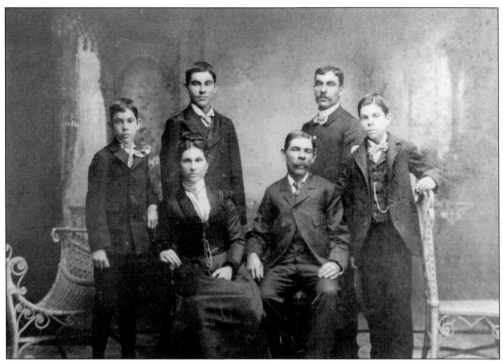

The Madruga family—including Manuel Francisco, his wife, Rosalina, and his sons Manuel Jr. and Harry—was the first Portuguese family to settle in San Diego in 1884. Manuel Madruga is credited with launching the Portuguese fishing industry by fishing mostly skipjack, mackerel, and barracuda. He is also responsible for having established the Portuguese settlement of La Playa in Point Loma. (Courtesy of the Portuguese Historical Center.)

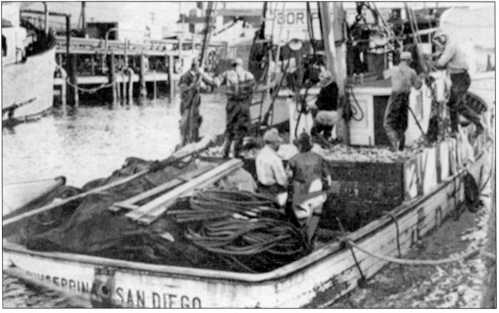

The *Giuseppina* delivers a load of sardines to the Sun Harbor Cannery in the 1950s. The sardines in this delivery were used for cattle and chicken feed. (Courtesy of the Tarantino family.)

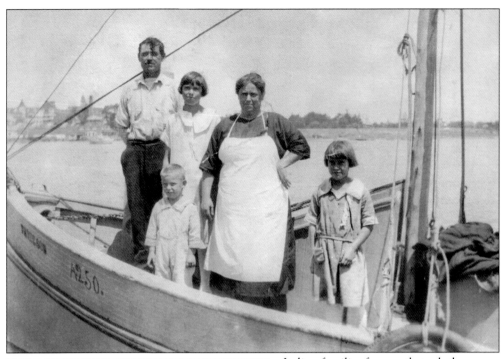

Italian families frequently took the family fishing boat to Coronado for a picnic. The Vattuone-Castagnola family poses on their boat, the *Three Sons*, in front of the Hotel Del Coronado as they enjoy their family outing on the bay around 1930. The youngest child is Italo "Babe" Vattuone, who still lives in San Diego today. (Courtesy of the Castagnola and Vattuone families.)

From left to right, John Canepa, his brother Angelo Canepa, and their great uncle Giovanni Zolezzi are pictured here on the family's fishing boat, the *San Giovanni*, around 1942. Behind them is Westgate Cannery, one of the earliest and most lucrative fish-packing companies in San Diego. (Courtesy of John Canepa.)

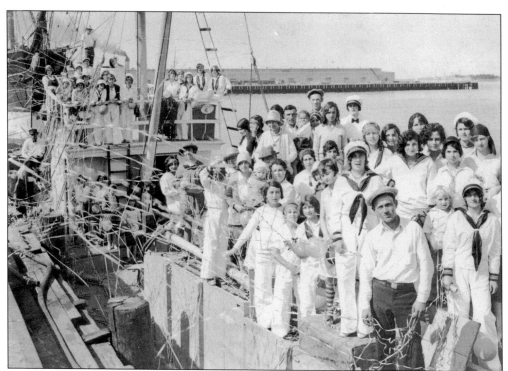

Confetti flies as family and friends prepare for a festive outing aboard the *Conte Verde*, owned by the Massa and Castagnola families, in the late 1920s. The *Star of India*, the world's oldest active ship and an emblem of the fishing industry and harbor life in San Diego to this day, is anchored behind. (Courtesy of the Massa, Castagnola, Navarra, and Vattuone families.)

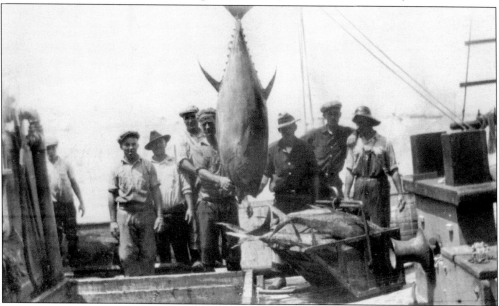

The crew returns with their big catch of the day. Among the fishermen are the Castagnola brothers—John, Louis, and Andrea—with Laurie and Steve Massa. (Courtesy of the Massa, Castagnola, Navarra, and Vattuone families.)

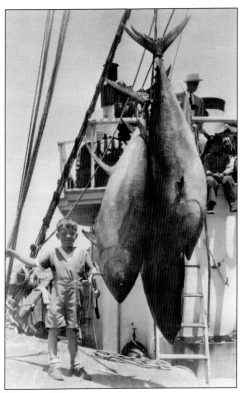

A budding fisherman holds the hook, standing proudly by the crew's triple catch. Many San Diegan residents fondly recall their excitement as children: waiting for the fishing boats to return from sea and then watching the fish being unloaded from the boats to the wharf or delivering the fish to the canneries. (Courtesy of the Maritime Museum of San Diego.)

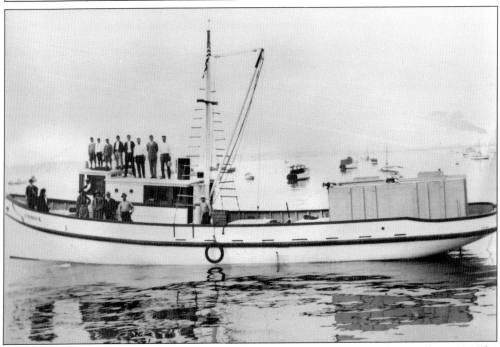

This image captures Portuguese family and friends aboard the *Lisboa* on its trial run in the 1920s. The inaugural launch and subsequent trial run of the family fishing boats were tremendously important and highly celebrated events in San Diego. (Courtesy of the Portuguese Historical Center.)

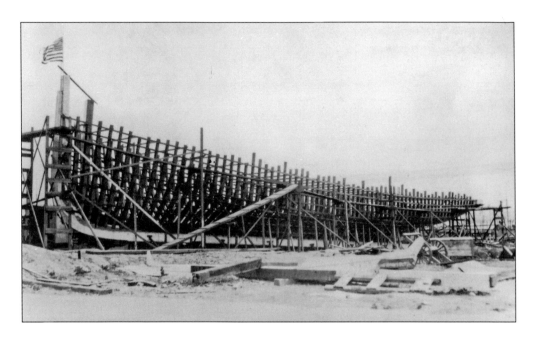

The photograph above shows the wooden hull of the *Stella Di Genova*, owned by tuna pioneer Giovanni Canepa, during its construction in 1928 by the Peter Rask Shipyard in San Diego. As did many Italians who settled in San Diego, the Canepa family emigrated from Riva Trigosa, Genoa, in Italy in 1902, heading first to San Francisco, then moving down to San Diego after the 1906 earthquake. The picture below captures the first sail of the *Stella Di Genova* on the day of its inaugural launching with friends and family aboard. (Courtesy of the Castagnola family.)

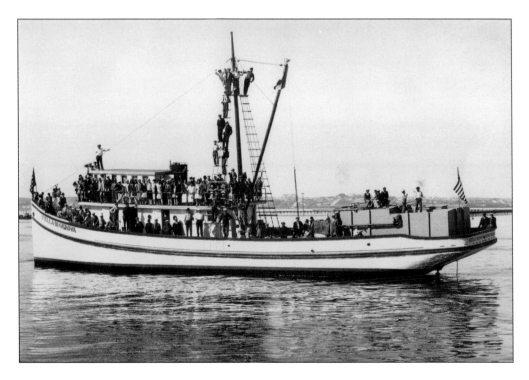

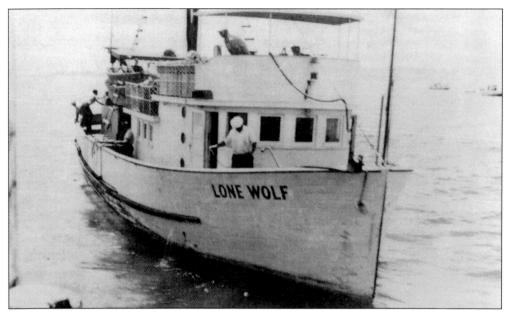

The *Lone Wolf* pictured above was a wooden bait boat built by John B. Zolezzi in 1937. The boat established the Zolezzi family in San Diego's tuna-boat fleet. Julius Zolezzi built the all-steel, high-tech super seiner, also named *Lone Wolf*, in 1982. The $10 million tuna boat was one of the last built for the U.S. fleet. (Courtesy of the Portuguese Historical Center.)

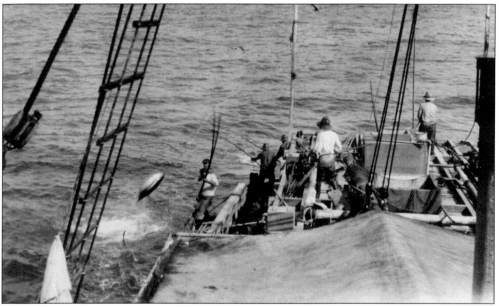

Japanese fishermen are pictured here two-pole fishing at the stern of an unidentified tuna clipper in the 1930s. The Japanese are credited with introducing a fishing technique that dramatically changed the American tuna industry. Rather than rely on net fishing, the Japanese began to fish for tuna by utilizing a long, flexible, and exceedingly strong bamboo pole. Whereas net fishing meant a larger catch, the process resulted in damaged canned-tuna meat. It took no time at all for the San Diego canneries to rely upon and promote bamboo-pole fishing as the preferred method for catching tuna. (Courtesy of the Maritime Museum of San Diego.)

Pictured here is the 1930 seaman's identification card for Louis Castagnola, a major tuna pioneer in San Diego who would go on to build a fleet of tuna boats. The U.S. Department of Labor issued such identification cards for immigrant fishermen in addition to the requisite licenses to fish. (Courtesy of Mr. and Mrs. Louis Castagnola and sons.)

The *Galileo*, owned by the Cresci family, sits at Fisherman's Wharf in San Francisco c. 1926, prior to being harbored in San Diego. At this time, it was not uncommon to expedite the design and building of a fishing boat in surrounding Southern Californian fishing cities such as San Francisco, Monterey, or San Pedro, for example, and then sail it down to San Diego thereafter. (Courtesy of the Cresci family.)

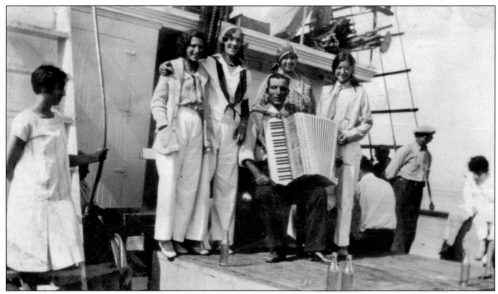

The fishing boats were not merely tools of the trade; they also served as floating "homes" on the sea for family and community gatherings. Indeed, the fishing boats were often named after places or people that were of personal significance to the family. Here the Cresci family gathers on the *City of San Francisco* around 1938. Playing the accordion is the co-owner of the fishing boat, Gaetano Cresci. (Courtesy of the Cresci family.)

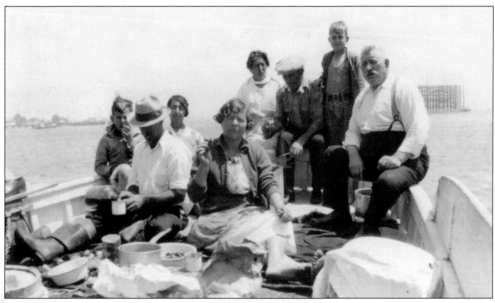

The Dentone and Carniglia families—originally from Genova, Italy—head to Coronado for the day, which was a popular pastime for fishing families, around 1925. (Courtesy of Sal Corona.)

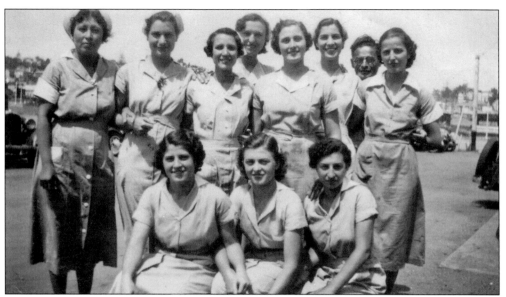

The fishing canneries provided employment for many of San Diego's residents, especially women, during the 1920s and 1930s. This group of young women was employed by Westgate Cannery and is pictured here outside the company in 1936. Sarah Gangitano Bono is kneeling in the first row on the left; others in the photograph are unidentified. (Courtesy of Marie Bono Sohl.)

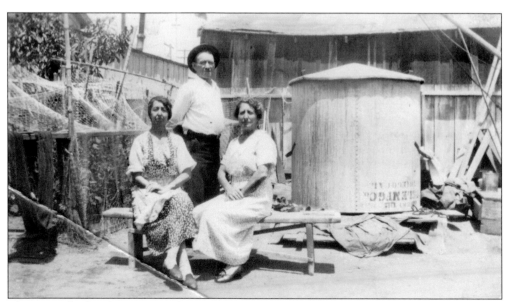

The Carniglia family poses in its backyard on Kettner Boulevard in Little Italy around 1930. The yards in the Italian neighborhood in San Diego were frequently used to store boats, maintain the fishing gear, and, especially, to mend the nets. The large vat contains the dye used in the process of coating the cotton-mesh fishing nets. (Courtesy of Sal Corona.)

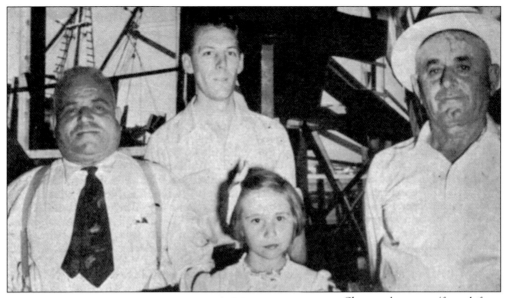

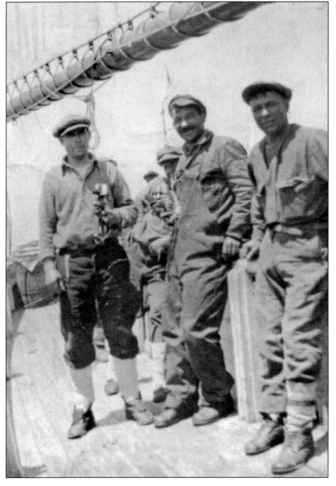

Shown above are (from left to right) Joe Bernardino, Adolph Larson, Lena Iacobellis, and Agostino Ghio (the boat's owner) following the launching ceremony of the *North America* in 1941. Lena, the young girl pictured here, christened the boat. The *North America* was one of hundreds of fishing boats in San Diego to be conscripted by the navy during World War II. (Courtesy of James Bregante.)

In the last decades of the 19th century and the first few decades of the 20th century, the earliest fishermen in San Diego spent weeks, and sometimes months, on fishing expeditions that took them far from home, such as fishing for salmon in Alaska. The fishing boats were tall-masted sailing boats, such as the Gloucester schooner pictured at left. Manuel J. Lester (right) sailed on Gloucester schooners in the late 1920s. (Courtesy of the Portuguese Historical Center.)

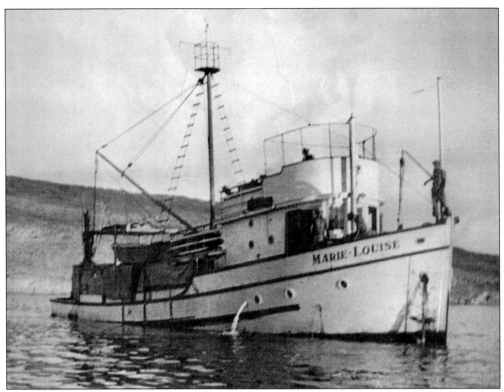

Approximately 15 percent of the tuna boats operating out of San Diego were owned and operated by Italian fishermen in the mid-1930s. A fine example is the *Marie Louise,* owned by Angelina, Stephen, Frank, and Lorenzo Zolezzi. (Courtesy of the Stephen Zolezzi family and the Francesco Alioto family.)

Dominic Ghio and his wife, Edelwies, enjoy the afternoon on their family boat, the *Star of Italy,* in San Diego Bay in the 1930s. (Courtesy of Mario Ghio.)

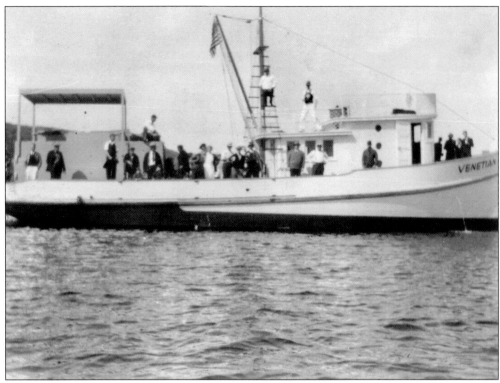

This photograph celebrates the trial run of the *Venetian*, which was built for $21,000 in 1935. The boat, owned by Steve Stagnaro, was his first. He also served as the skipper. (Courtesy of the Stagnaro family.)

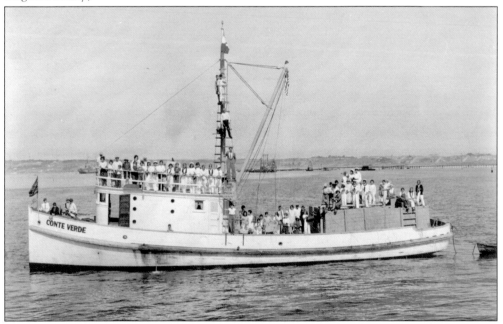

Family and friends are shown aboard the *Conte Verde*, owned by the Massa and Castagnola families. (Courtesy of the Massa, Castagnola, Navarra, and Vattuone families.)

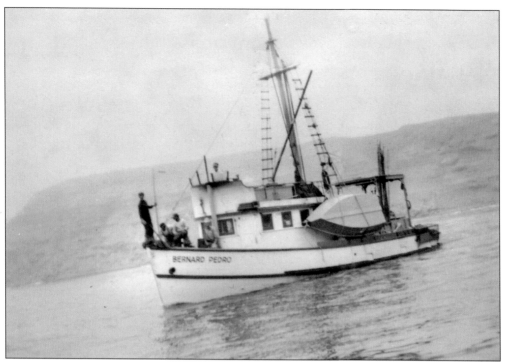

Although they were met with challenges during the Depression and World War II, many fishermen continued to rely on the trade for their livelihood well into the late 1970s. This boat, the *Bernard Pedro*, pictured here around 1947, typifies the boats used for smaller fishing expeditions in the postwar years. The skipper was Frank Mangiapane. (Courtesy of Ed Pecoraro.)

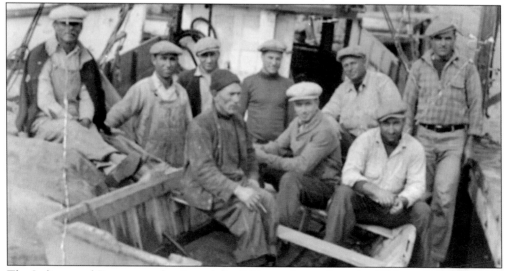

The Italians and Portuguese dominated the fishing industry from the 1920s to the early 1940s. This boat was originally owned by a Portuguese family, but it was then sold to an Italian fishing family, which was not atypical. The crew, along with the boat's owner, Giuseppe Corona (second from left), are pictured on the *Buoa Viage* around 1930. Corona purchased the *Buoa Viage*, his second boat, from Harold Medina, a Portuguese pioneer in San Diego's tuna industry. (Courtesy of Sal Corona.)

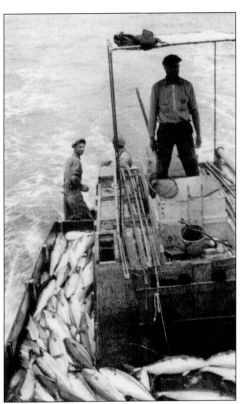

Ignazio Asaro and the deMaria brothers fish on the *White Star* around 1936. (Courtesy of Andrew Asaro.)

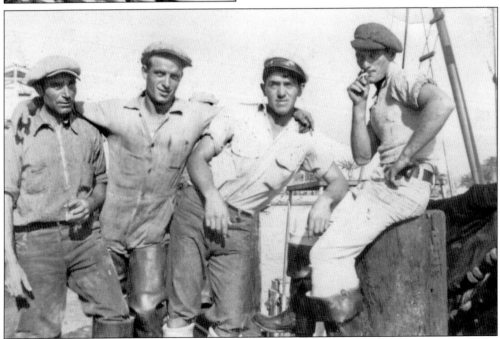

Vito Zottolo (third from left) is pictured around 1940 with his chums on the boat *Roma* in San Diego Bay. Now in his 90s, Zottolo still has fond recollections of the camaraderie shared on the fishing boats. (Courtesy of the Zottolo family.)

From left to right, Lillian, Elsie, and Andy Stagnaro attend the launch of the *Venetian* in 1935. (Courtesy of the Stagnaro family.)

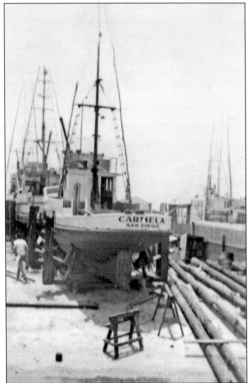

The boat *Carmela* sits on the ways—the drydock—at the Pete Rask Boatyard in the early 1950s. Pete Rask was the son of a Danish boatbuilder who immigrated to San Diego in the late 19th century. He began an apprenticeship as a boatbuilder in 1911 at the age of 10. One of the first boats built by his family's boatbuilding company was the 50-foot *Pacific*, built for the Portuguese tuna-fleet pioneer Joaquin Medina. (Courtesy of the Tarantino family.)

TUNABOATS DOMINATOR, SUN VALLEY FALL VICTIM TO SEA HAZARDS

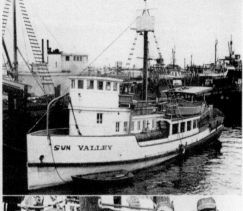

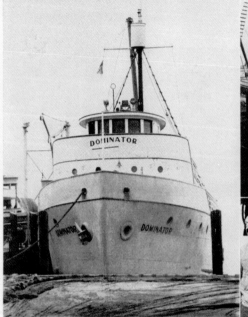

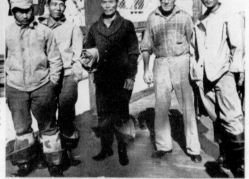

The 126-foot Dominator, which was the largest steel-hulled vessel in the tuna industry when it joined the Sun Harbor fleet in 1945, was destroyed after going aground in the Galapagos Islands last month. The clipper had been released by Sun Harbor for that trip to operate for another cannery.

* * *

Perils of Sea Claim Three Well-Known Tuna Clippers

Three vessels which had operated in the Sun Harbor tuna fleet became victims of the sea in recent weeks.

They are the 58-foot Sun Jacket, the 80-foot Sun Valley, and the 126-foot Dominator.

The Sun Jacket, which was on its last trip for Colombian fishing interests prior to rejoining the Sun Harbor fleet after a year in the South American service, crashed on a rocky beach at the Galapagos Islands Nov. 24.

CAPT. DONALD L. BYRD and his wife, JENNY, were among the six aboard. All were saved when they escaped in two skiffs and rowed for 10 hours until picked up by the San Diego tunaboat United Victory. Mr. and Mrs. Byrd were transferred to the clipper Heroic, which brought them home. The other four, three Ecuadorians and a Colombian, returned to the South American mainland in a freighter.

The Sun Valley, with 9 crewmen, burst into flames in Magdalena Bay, Baja California, last month, exploded and sank. The entire crew were picked up by the clipper North Star nearby, and were eventually brought to San Diego on the United Victory and Sea Boy.

One of the oldest vessels in the tuna fleet—it was built 23 years ago—the Sun Valley in the last 2 years had been modernized with installation of $50,000 worth of new eqpipment. Its crew, primarily Japanese-Americans, included the following:

CAPT. ROY MORINAKA; RICHARD PEFLEY; MASATO "GEORGE" UDA; YOSHIRO NISHIMURA; NOAH KEALOHA; MASARU YANAGIHARA; TOJU KOIDE; MINORU OZAKI, and HISASHI OZAKI.

Only Uda and Nishimura were

(Continued on Page 4)

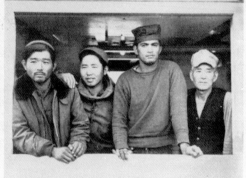

Disaster overtook the 23-year old 80-foot Sun Valley, one of the oldest clippers in the tuna fleet, when it burst into flames in Magdalena Bay last month. It had been completely modernized with $50,000 worth of new equipment during last two years. Crew members are shown as they returned to San Diego aboard two other vessels. In center photo are left to right, Roy Morinaka, Sun Valley captain; Hisashi Ozaki, Tajo Koide, Richard Pefley, and Minoru Ozaki. In lower photo are left to right, George Uda, engineer; Yoshiro Nishimura, Noah Kealoha, and Masaru Yanagihara, cook.

This image from the *Catch and Can*, a monthly newsletter published by the Sun Harbor Cannery, reveals the ethnic diversity of the fishing industry. It also points to the dangers that were faced by all fishermen. In 1950, the *Sun Valley* burst into flames at Magdalena Bay in Baja, California, and sank. (Courtesy of the Tarantino family.)

Two

A CATCH-ALL INDUSTRY
FISHING AND COMMUNITY

From left to right, Vito Romani, Louis Guidi, Giulio Guidi, and Gus Guidi stand on the bridge of the *Lou Jean* for the 1946 launch. Many of the fishing boats were named after family members. Those who grew up in San Diego during the height of the fishing industry, for example, can easily recall the names of dozens of tuna boats because they were the namesakes of grandparents, uncles and aunts, and other family relations. (Courtesy of the Guidi family.)

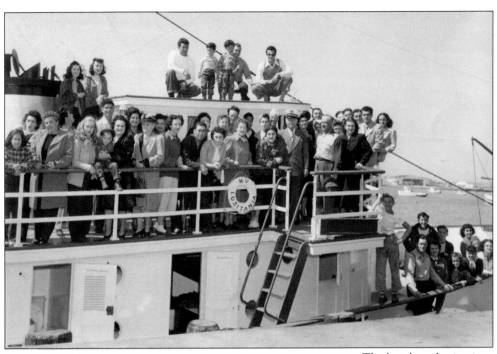

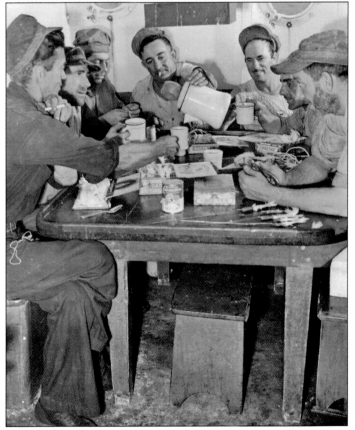

The bait boat *Lusitania* was owned by Manuel Rosa, a pioneer in the Portuguese fishing industry in San Diego. Friends and family gather on the *Lusitania* as it sails on its trial run in 1941. (Courtesy of the Portuguese Historical Center.)

The crew stops briefly for a coffee break amidst bait and tackle on the *Sun Harbor* around 1944. (Courtesy of the Crivello family.)

Vito Zottolo (center) stands aboard the *Sacramento* around 1935. While fishing for bait in Coronado, the crew of the *Sacramento* was joined by the two bathing beauties posing here. Apparently, the young women spotted the boat from the shore and asked to come aboard, making for a most pleasant day of fishing. (Courtesy of the Zottolo family.)

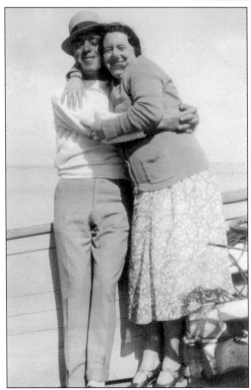

Steve and Katie Stagnaro embrace one another aboard the *Venetian* on the day of its trial run in 1935. The Stagnaro couple, like so many Italians who immigrated to California in the early 20th century, moved from San Francisco after the 1906 earthquake to build a new life in San Diego. (Courtesy of the Stagnaro family.)

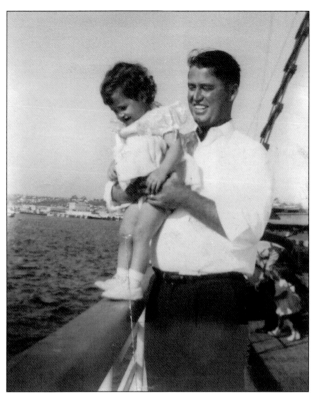

In the picture at left, Louis Vattuone holds his young daughter Maria on the Motor Vessel (MV) *Commendore* in 1949. Below, Vattuone and Maria (right) are joined by Frank Alioto and his daughter Donna Marie. (Courtesy of Frank and Bianca Alioto and family.)

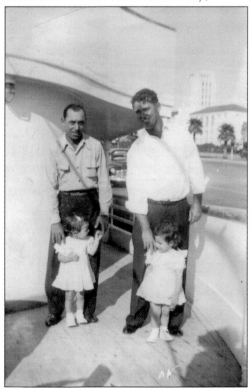

Andrea Castagnola, a pioneer in the fishing industry in San Diego, stands with his wife, Preziosa Zolezzi Castagnola. The Castagnolas immigrated to San Diego after the San Francisco earthquake and established themselves in the fishing industry soon thereafter. The Castagnola's first boat was the 46-foot *Caterina Madre*, on which they fished locally for rock cod and sea bass. (Courtesy of the Castagnola family.)

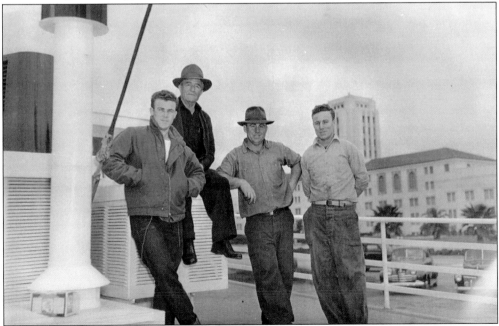

From left to right, Joe, Andrea, Louis, and John Castagnola are pictured here aboard the *Conte Di Savoia*, built in 1947, along the San Diego Embarcadero. Andrea Castagnola, along with his sons and sons-in-law, Stefano and Lazzaro Massa, owned and operated the bait boats the *Conte Verde*, *Conte Bianco*, and the *Conte Grande*. (Courtesy of the Castagnola family.)

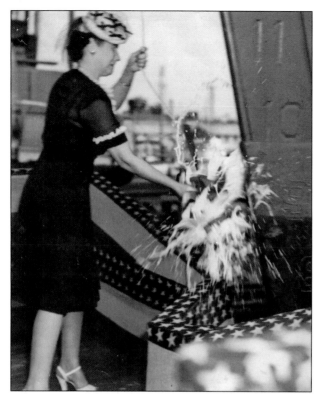

During World War II, many fishing boats were requisitioned by the U.S. Navy as Yacht Patrols (YP), or "Yippies." This image captures the christening of a converted tuna boat to a YP vessel in 1941. As was the tradition, the boat is ceremonially "baptized" by breaking a bottle—most often champagne—at its bow. Women, and sometimes young girls, were often called upon to do the christening. (Courtesy of the Portuguese Historical Center.)

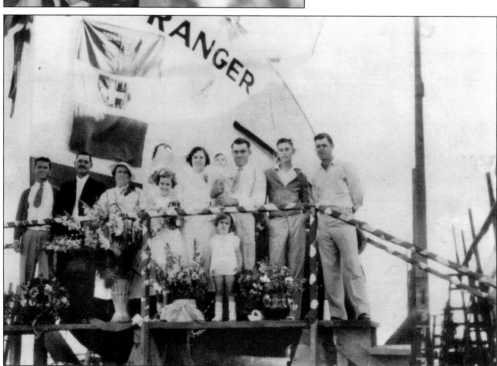

The family gathers for a photograph at the blessing of the *Ranger* in 1936. The captains were John and Louie Vattuone. (Courtesy of the Castagnola and Vattuone families.)

H. O. Medina, a Portuguese pioneer in the fishing industry in San Diego, stands in front of his boat, the *Atlantic*, one of the earliest of its class of large tuna boats. The *Atlantic* was built by Campbell Industries in 1926. (Courtesy of the Portuguese Historical Center.)

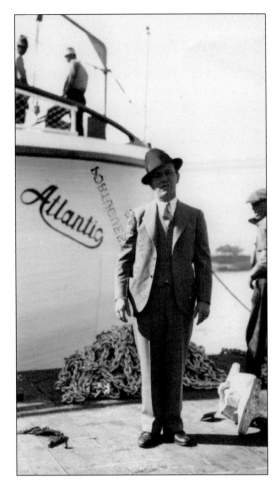

Joe Madruga poses with his son in front of the family boat, the *Paramount*. The *Paramount* was one of a number of fine tuna seiners that made up the Madruga family fleet. (Courtesy of the Portuguese Historical Center.)

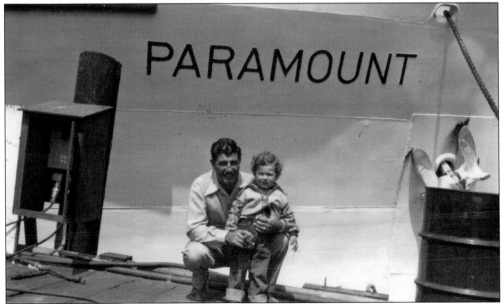

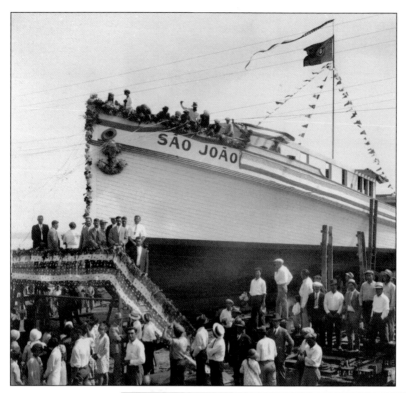

The Portuguese-owned *Sao Joáo* was christened in the 1930s. Christenings among the Italian and Portuguese families were baptisms of a different sort. As was the practice within the church, the ceremony at the wharf, commemorating the trial run of the fishing boat, was often presided upon by the neighborhood priest. (Courtesy of the Portuguese Historical Center.)

Local community leaders and businessmen observe one of the most significant steps in hauling in the tuna catch on a purse seiner: the pulling in of the rings. In this process, the rings of the purse are drawn in so as to close up the net around the fish as the catch is brought aboard. The shift from bait boat to purse seiner was a major evolution in San Diego's fishing industry. (Courtesy of the Portuguese Historical Center.)

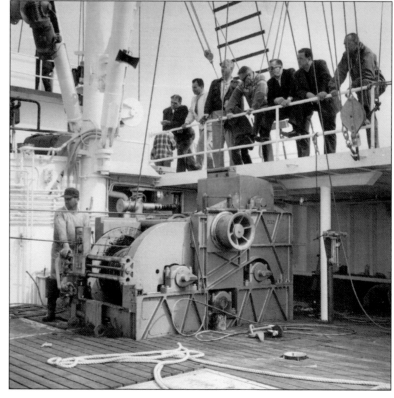

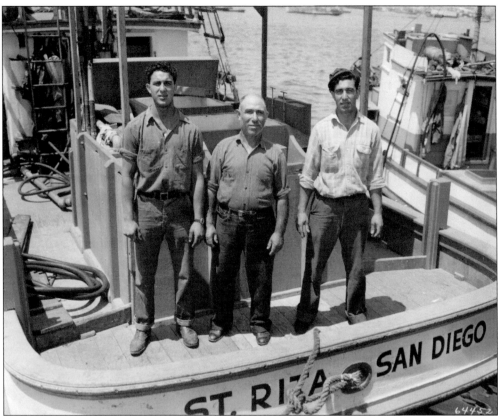

Above, the Corona family boat, the *St. Rita*, built after the war, is pictured around 1949. In the center stands patriarch Giuseppe Corona, flanked by his two sons, Frank (left) and Donald. The boat was used for catching albacore during the regular fishing season and for catching sea bass during the off-season months. (Courtesy of Sal Corona.)

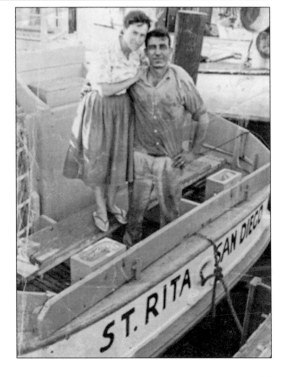

Pictured in Point Loma, Donald and Concetta Corona anchor while posing for a photograph on the family boat during their day trip around the San Diego Bay in 1963. (Courtesy of Sal Corona.)

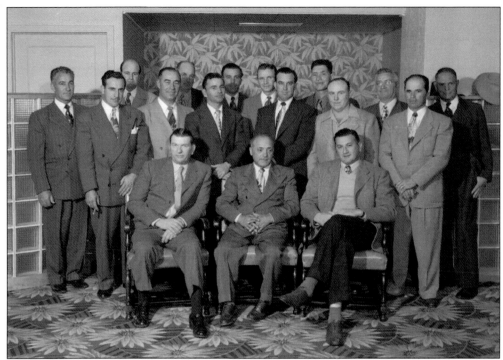

Organized largely by Italian and Portuguese shipbuilders and boat owners, the American Fishermen's Tunaboat Association was founded in the late 1920s to represent tuna-boat fisherman and protect the industry. It later became the American Tunaboat Association (ATA). Here members of the ATA take a break from their business proceedings to pose for a photograph. (Courtesy of the Portuguese Historical Center.)

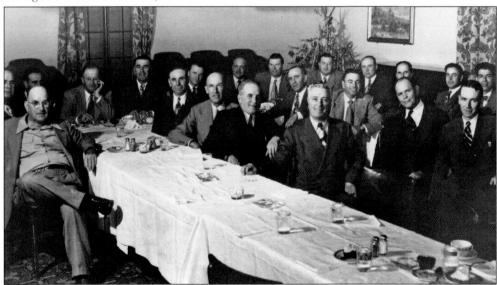

Members of the ATA are pictured during the holidays. More recently, August Felando managed the operations of the American Tunaboat Association from 1961 until 1990; he remains involved with the organization and continues to represent fishermen in San Diego today. (Courtesy of Mr. and Mrs. Louis Castagnola and sons.)

Frank Alioto and his daughter Donna Marie pose on the MV *Commendore* in 1949. Children were frequently brought aboard the fishing boats for inaugural launches or family outings. (Courtesy of Frank and Bianca Alioto and family.)

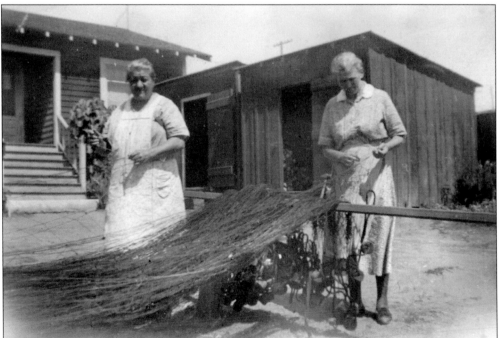

While the men were off fishing, the women contributed to the enterprise by mending the fishing nets. Gemma Stagnaro (left) and Angelina Canepa are seen here in the backyard of the Little Italy neighborhood around 1940. (Courtesy of Frank and Bianca Alioto and family.)

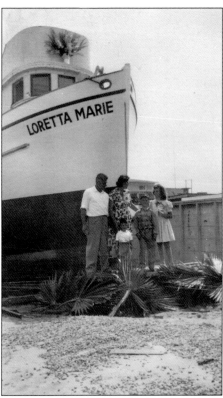

The family stands before the family boat, the MV *Loretta Marie*. Shown are Alfonso Stagnaro, his wife, Louise, and his three children, Loretta, John, and Louis. (Courtesy of Frank and Bianca Alioto and family.)

Frank Alioto and his daughters Donna Marie (left) and Catherine are pictured on the MV *Commendore* in 1962. (Courtesy of Frank and Bianca Alioto and family.)

A procession for the Festa of Madonna del Lume ("Lady of Light") at Our Lady of the Rosary Parish celebrates a bountiful harvest and a safe return for the fishermen. This tradition began in the 1930s when the first fishermen from Porticello, Sicily, arrived in San Diego. The tradition continues to this day. (Courtesy of Frank and Bianca Alioto and family.)

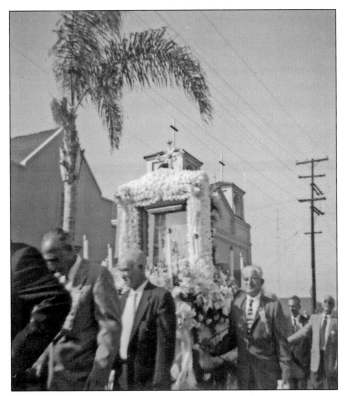

Fishermen play boccie ball in Little Italy, one indication that the fishing conditions were poor that afternoon. Pictured in 1945 are, from left to right, Dominic Lalicata, Matteo Buompensiero, unidentified, Jack Marino, Nino d'Aquisto, Jack Sardina, and Frank Navarro. (Courtesy of Ed Pecoraro.)

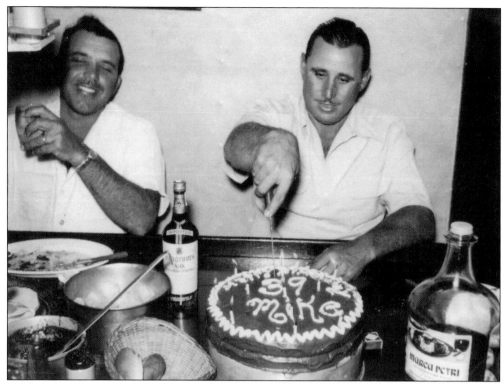

Celebrations continue on the boat in the same way that they would have on shore. Here Mike Bono celebrates his 39th birthday on the *Lou Jean* in 1957. Mike's brother-in-law, Lou Guidi, cheers him on. (Courtesy of Marie Bono Sohl.)

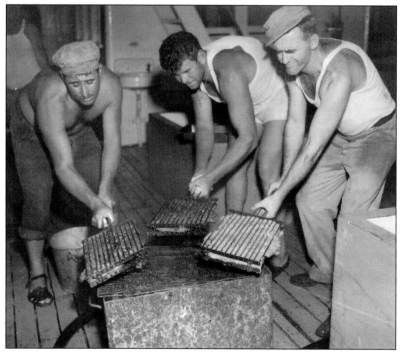

The fishermen worked up an appetite. Barbecues on the boat were popular because the men could quickly and easily cook their catch. Here Mike Bono (left) and his crewmen prepare dinner aboard the *Lou Jean* in 1955. (Courtesy of Marie Bono Sohl.)

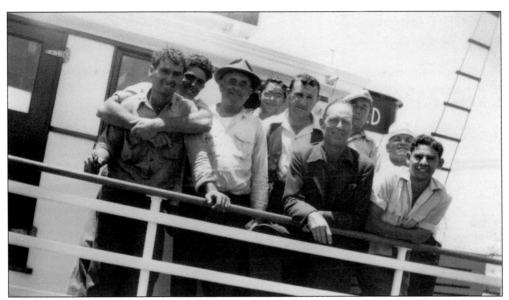

The *North America* arrives in port from a fishing trip in 1941. Among those pictured above are the skipper Fortunato Ghio (left), the boat owner Agostino Ghio (third from left), and James Bregante Sr. (fifth from left). (Courtesy of James Bregante.)

Standing aboard the *Venetian* in 1937 are, from left to right, Bartolo Stagnaro, Agostino Ghio, Steve Stagnaro (owner), and Gerolamo Bregante. (Courtesy of James Bregante.)

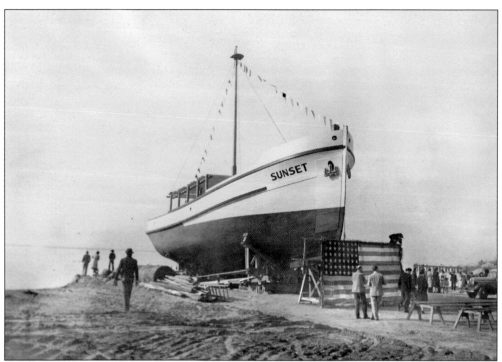

Family and friends gather for the christening and launching of the *Sunset*, the Bregante family's wooden-hulled boat, in the 1940s. (Courtesy of Anthony and Richard Bregante.)

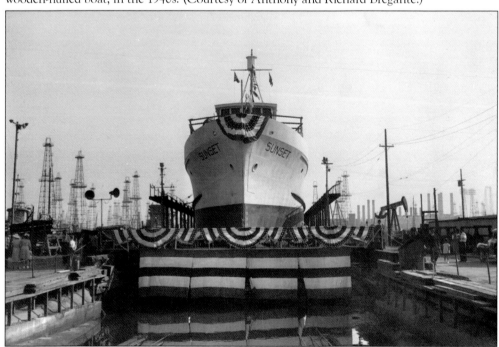

In 1946, the *Sunset* was replaced with its modern steel counterpart, the MV *Sunset*. This photograph captures the christening and inaugural launch of the new-and-improved fishing boat. (Courtesy of Anthony and Richard Bregante.)

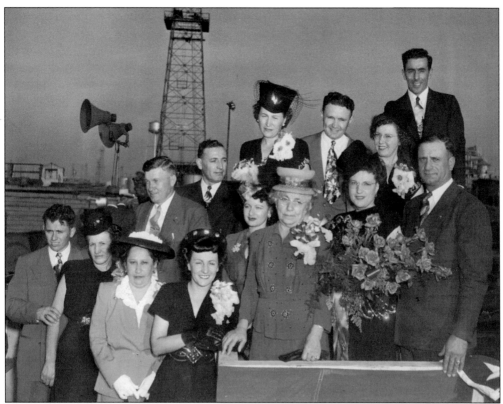

Capt. Mario Ghio (first row, far right) poses with the Bregante and Ghio families for a ceremonial photograph at the launching of the modern *Sunset* in 1946. (Courtesy of Anthony and Richard Bregante.)

Gerolamo Bregante is shown aboard the MV *Europa*, owned by Mariano Crivello, around 1930. Bregante, seen here delivering a speech for the boat's trial run, was on the Port Commission's board at this time. He was also on the board of directors for the Bank of Italy, which later became Bank of America. (Courtesy of the Stagnaro family.)

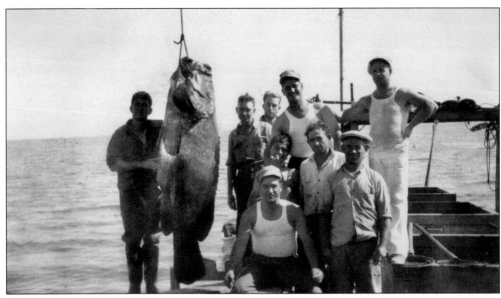

The 1934 crew of the *City of San Francisco* proudly displays their sea bass, caught at Magdalena Bay, in Baja, California. (Courtesy of the Zottolo family.)

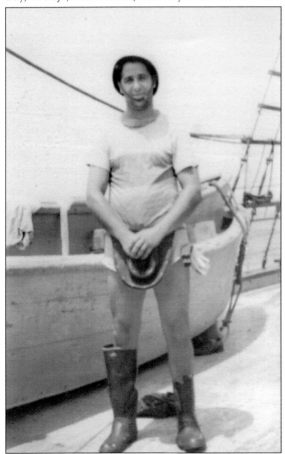

It was not always all business on the boat. Here Tony Balelo takes a break from fishing aboard the MV *Santa Margarita* to pose for the camera in 1940. (Courtesy of the Portuguese Historical Center.)

The crew pauses for a midday snack on deck the *Sun Harbor* in 1944. Fishing and the fresh sea air made for hearty appetites. Among the delicacies provided to the crew was a specially prepared Italian spinach dish with garlic, olive oil, and tomatoes. (Courtesy of the Crivello family.)

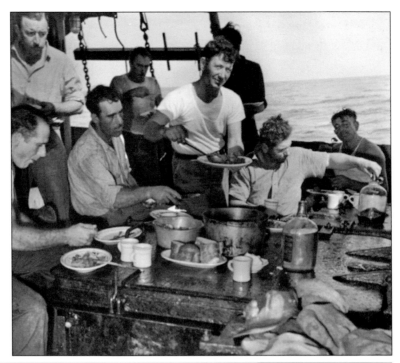

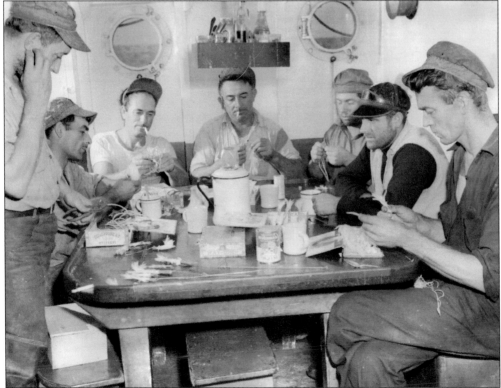

After a coffee break, the men return to preparing the hooks with squid as bait aboard the *Sun Harbor* in 1944. (Courtesy of the Crivello family.)

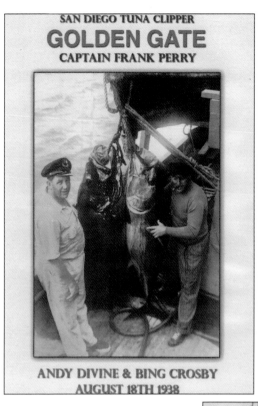

SAN DIEGO TUNA CLIPPER

GOLDEN GATE
CAPTAIN FRANK PERRY

ANDY DIVINE & BING CROSBY
AUGUST 18TH 1938

Frank Perry (behind the catch), pioneer in the tuna-fishing industry, was also captain of the sports-fishing boat the *Golden Gate*. On this occasion in 1938, he proudly hosts the famed celebrities Andy Divine (left) and Bing Crosby (right) aboard for a marlin-fishing expedition. (Courtesy of the Portuguese Historical Center.)

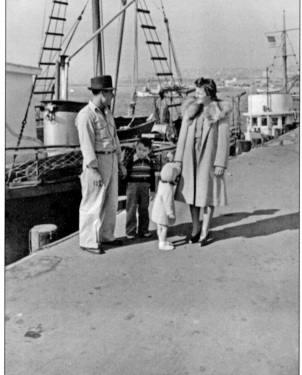

Skipper Sam Crivello bids farewell to his wife and young children, Mario and Esther, as he prepares to board the *Sun Harbor* at the Embarcadero in 1944. One of the most difficult aspects of fishing was the time spent away from family. (Courtesy of the Crivello family.)

Roosevelt Junior High School students don fishing costumes in 1938 to celebrate Costume Day at the school. The boys are dressed in oil skins and carry bamboo fishing poles, and the girls wear traditional costumes. (Courtesy of Andrew Asaro.)

From left to right, Tony Giacalone, Gus Guidi, Mike Bono, and Vito Zottolo are pictured here on the deck of the *Kathryn* in 1939. (Courtesy of the Guidi family.)

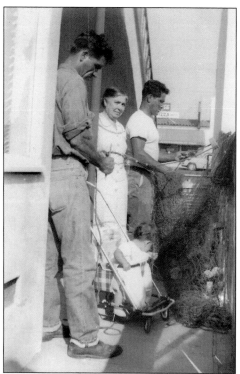

At the back of their house on India Street, Joe and John Tarantino mend the lead line of the bait net by hand for the *Carmela* in 1955. Joe's mother-in-law, Nina Valenti, and Joe's baby boy, Anthony, lend a hand. (Courtesy of the Tarantino family.)

The Vattuone family boat, the *Commodore*, is christened in 1941. At the outbreak of World War II, the U.S. Navy conscripted the MV *Commodore* as a Yacht Patrol, designating it as YP 515. It was sent out to the South Pacific Ocean to carry supplies to forward bases during the war and to defend against enemy submarine attacks. (Courtesy of the Castagnola and Vattuone families.)

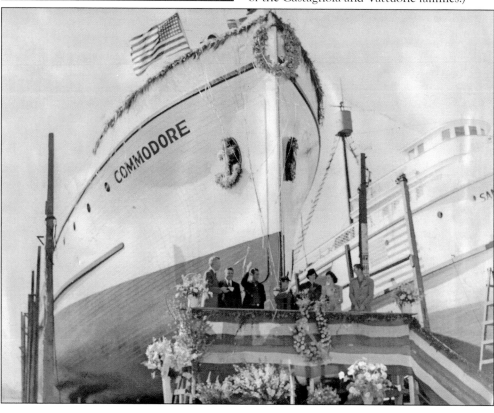

Three generations of women gather for the launching of the *Lou Jean* in 1946. Pictured from left to right are Catherine Romani (named after her grandmother), Vera Romani, Frances Guidi, Mary Guidi, and Catherine Romani. (Courtesy of the Guidi family.)

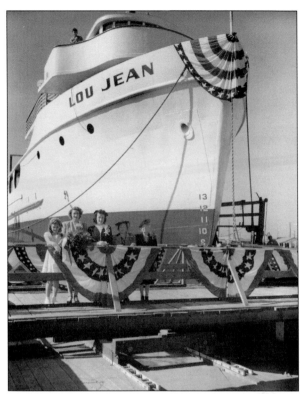

Sara Guidi and Linda Guidi celebrate the completion of the *Lou Jean II*, a modern purse seiner designed by Arthur DeFever in 1969. DeFever has achieved renown as a naval architect and yacht designer, beginning his career in San Diego in the 1940s by designing tuna clippers such as the beautiful *Lou Jean II*, shown here. (Courtesy of the Guidi family.)

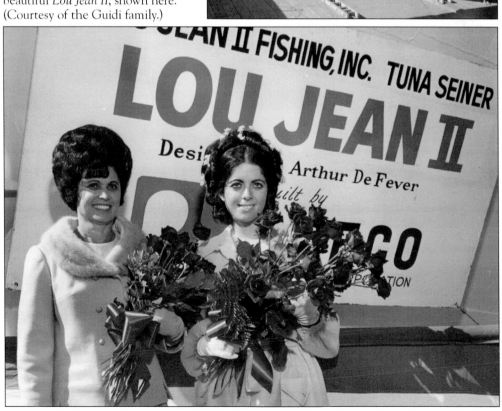

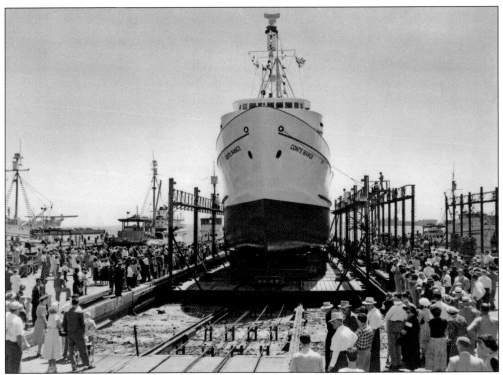

A Castagnola steel boat, the *Conte Bianco,* is christened in 1951. (Courtesy of Mr. and Mrs. Louis Castagnola and sons.

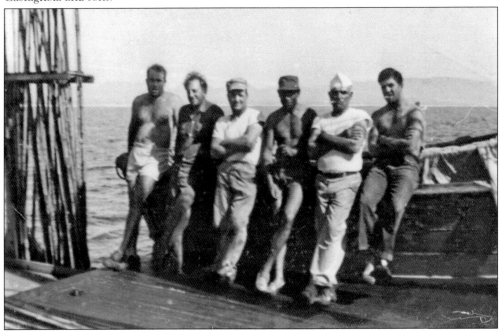

A crew of Sicilian fishermen stands aboard the *Invader* off the coast of Panama in 1950. Among the crew are two brothers (pictured first and fourth from left) Benedetto and Stefano Brunetto; the others are not identified. (Courtesy of the Brunetto family.)

The *Conte Bianco* was rebuilt as a steel ship by the National Steel and Shipbuilding Company (NASSCO) in 1951. NASSCO began as a small machine shop and foundry known as California Iron Works in 1905. In 1922, it was renamed National Iron Works; 11 years later famed shipbuilder C. Arnholt Smith acquired the company. In 1949, the company was renamed National Steel and Shipbuilding Company to reflect expansion into ship construction, and it rivaled Campbell Industries as a major shipbuilding company in San Diego. (Courtesy of Mr. and Mrs. Louis Castagnola and sons.)

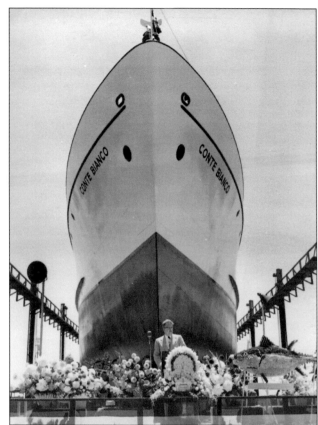

At the launch of the steel tuna seiner *Conte Bianco*, in 1951, the Van Camp Seafood Company, one of the largest tuna-canning companies in San Diego, celebrates with good wishes as well. (Courtesy of Mr. and Mrs. Louis Castagnola and sons.)

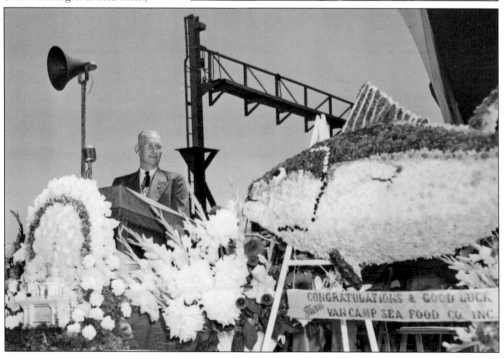

The *Antonina* C was built at San Diego Marine Construction for Louis Castagnola around 1970. This boat was the first of three seiners built for the Castagnola family. Standing in front is the boat's namesake, Antonina Castagnola. (Courtesy of Mr. and Mrs. Louis Castagnola and sons.)

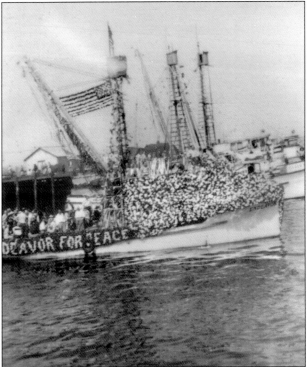

The *Endeavor* parades along the harbor decorated in flowers that spell "Endeavor for Peace." Flowers were used frequently as decoration to don the boats for christenings and trial runs. (Courtesy of the Tarantino family.)

Three

BAIT AND TACKLE
TOOLS OF THE TRADE

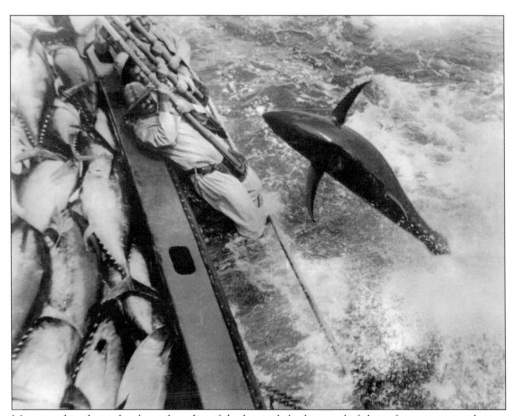

Men stand in the racks along the edge of the boat while three-pole fishing for tuna in rough seas. The larger tuna often ranged between 100 and 200 pounds, requiring two to three men to pull the fish aboard. (Courtesy of the Portuguese Historical Center.)

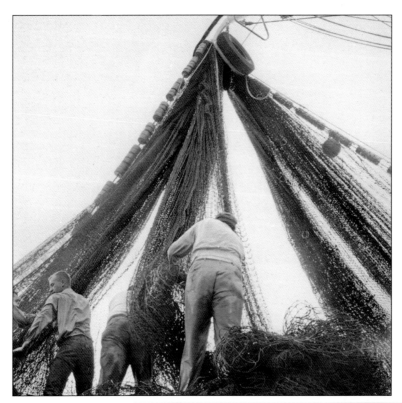

The purse seine made for a dramatic innovation in the tuna-fishing industry. Originally, the nets were made of heavy cotton, which meant that it required six to eight crewmen to haul the wet net aboard. In the early 1950s, the cotton purse seines were replaced by much lighter, yet equally durable nylon nets, resulting in another important innovation in the industry. (Courtesy of the Portuguese Historical Center.)

Yet another important technological innovation to the industry was the advent of power blocks, introduced in the mid-1950s. The power block is a mechanized pulley used to haul in purse seine nets along with the catch; what used to take the manpower of eight or more men is achieved with this mechanical invention. (Courtesy of the Portuguese Historical Center.)

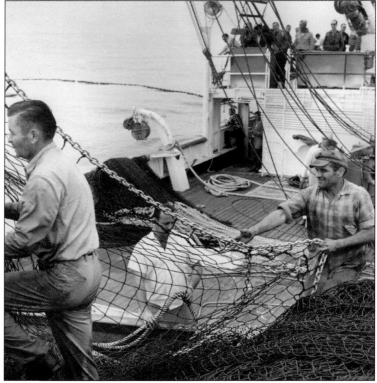

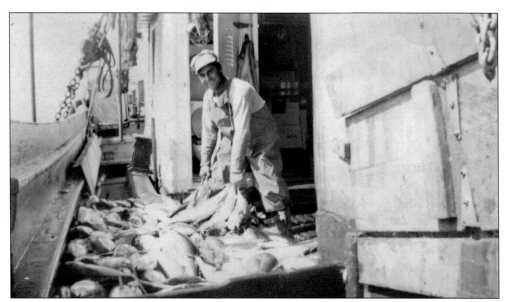

Pete Tarantino passes the tuna into the ice hole to stay fresh on the bait boat *Dependable* around 1947. The *Dependable* was owned by Carmelo Pecoraro, who was also the skipper. (Courtesy of Ed Pecoraro.)

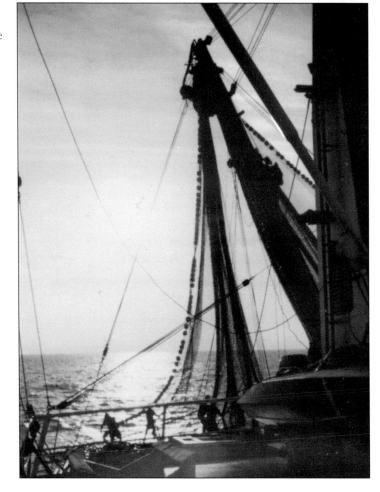

A sunset was photographed from aboard the *Margaret L*, named for Margaret Lococo, off the coast of Costa Rica in 1976. The boat's skipper was Spencer Brunetto. (Courtesy of the Brunetto family.)

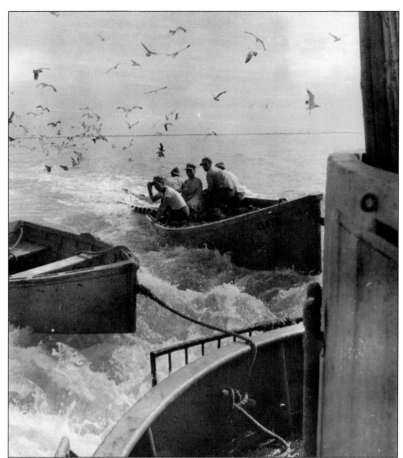

A smaller crew trails on the skiff with the *Sun Harbor* in tow around 1944. Although the presence of sea birds might be an indication of good fishing grounds, often the bait would drive skipjack to the surface, attracting the fish as well. (Courtesy of the Crivello family.)

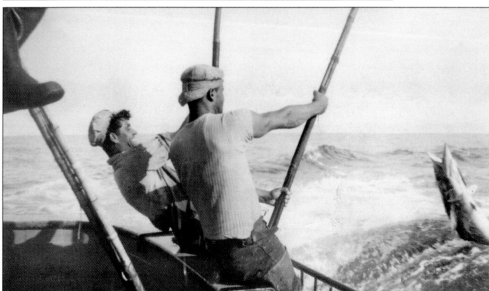

John Giammarinaro (left) and Joe Tarantino pull in a large wahoo tuna by the two-pole fishing method on the *Lou Jean* in 1948. (Courtesy of the Guidi family.)

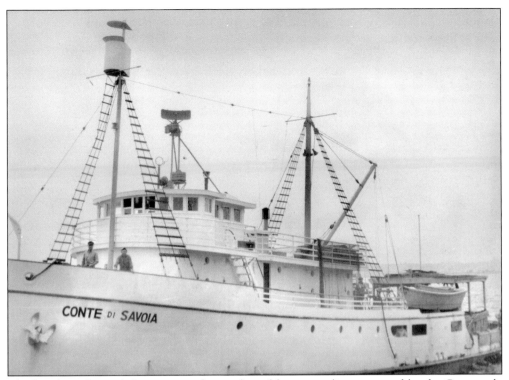

The bait boat *Conte di Savoia*, one of a number of fine tuna clippers owned by the Castagnola family, sits proudly in 1947. The boat was later sold to the famed shipbuilder C. Arnholt Smith. (Courtesy of Mr. and Mrs. Louis Castagnola and sons.)

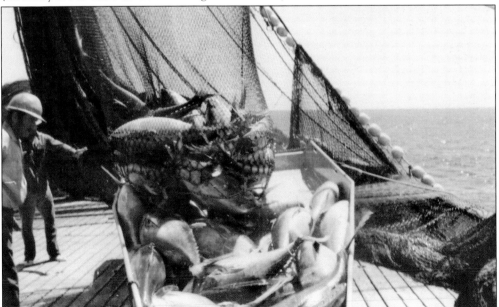

Crew members release the fish into the hopper, directing them into chutes leading to the brine-filled holding tanks aboard the *Margaret L.* Frank Piraino assures that only the best-quality fish get through the chute. (Courtesy of the Lococo family.)

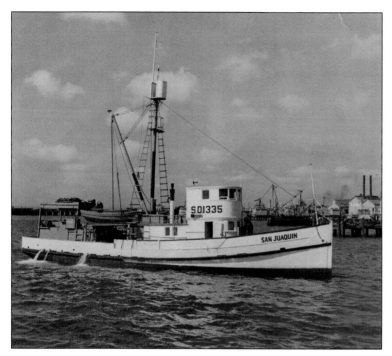

The *San Juaquin*, owned by Manuel "M. O." Medina, founder of the United Portuguese Sociedade do Espirito Santo Hall, is pictured at left. A prominent pioneer in the tuna-fishing industry, Medina is credited with sponsoring and organizing the first Portuguese festa, which is a community event that continues to be celebrated in San Diego annually. (Courtesy of the Portuguese Historical Center.)

Crew members practice the technique of two-pole fishing, whereby two heavy cotton lines are attached through swivels to a common ring, through which the leader and bait are fastened. Depending on the type and size of the fish, anywhere between one and four bamboo poles were shared by the fishermen to bring in the catch. (Courtesy of the Portuguese Historical Center.)

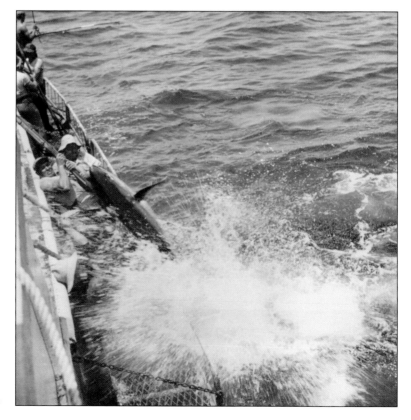

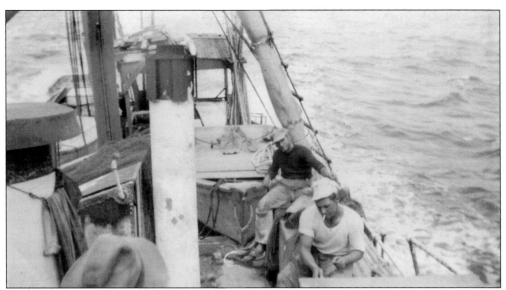

Carmelo Pecoraro and Pete Tarantino work on the fishing gear aboard the *Dependable* in 1947. The tackle in this case includes a striker, or squid, which consisted of a hook set of brass filled with white feathers to resemble live squid bait. (Courtesy of Ed Pecoraro.)

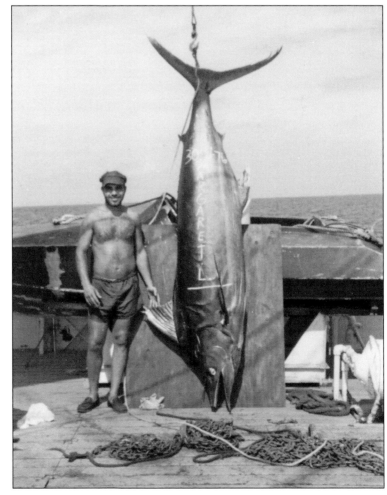

John Brunetto stands alongside the marlin he caught on the *Margaret L* in 1976. (Courtesy of the Brunetto family.)

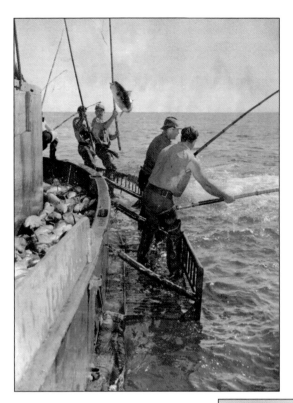

The crew fishes for lighter tuna using the one-pole fishing method on the *Sun Harbor* in 1944. (Courtesy of the Crivello family.)

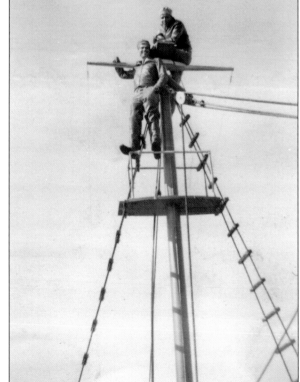

One way to spot bountiful fishing grounds was to climb up to the crow's nest in order to achieve a bird's-eye view of the ocean. Louis Guidi (left) and Gus Guidi are pictured on the yardarm above the mast of the *Kathryn* in 1939. (Courtesy of the Guidi family.)

The *Conte Bianco* is pictured after its conversion from a wooden bait boat to a steel boat at the docks in 1959. Also pictured is the *Jo Linda*, owned by the Guidi family, a boat that was also in the process of conversion to seiner. (Courtesy of Mr. and Mrs. Louis Castagnola and sons.)

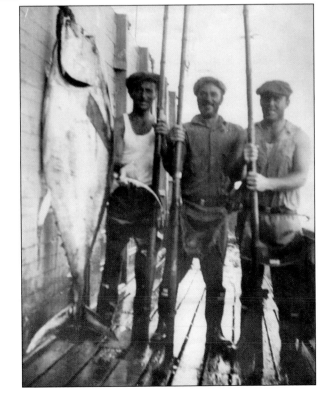

The crew—(from left to right) Steve Massa, Lazaro Massa, and Louis Castagnola—celebrates success after pulling aboard a large tuna using the three-pole technique. (Courtesy of Mr. and Mrs. Louis Castagnola and sons.)

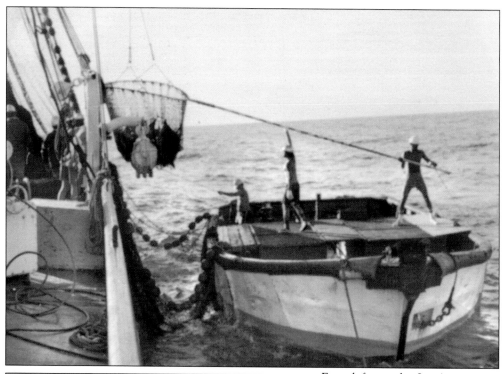

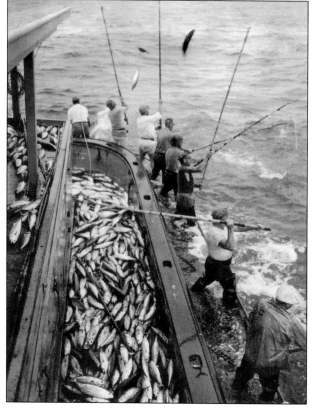

From left to right, Joe Asaro, nicknamed "Buckets," Vito Giacalone, the "Squirrel," and Sal Corona, the "Dog," practice the fishing technique of brailing yellowfin aboard the *Marla Marie* off the coast of Costa Rica around 1977. Brailing involves scooping with a smaller net to draw the fish out of the much-larger purse seine. (Courtesy of Sal Corona.)

The crew of the *Lou Jean* catches smaller-sized one-pole fish in 1950. Fishermen were always prepared with the appropriate gear in order to catch larger fish when available, and they would change the pole configuration as needed. (Courtesy of Marie Bono Sohl.)

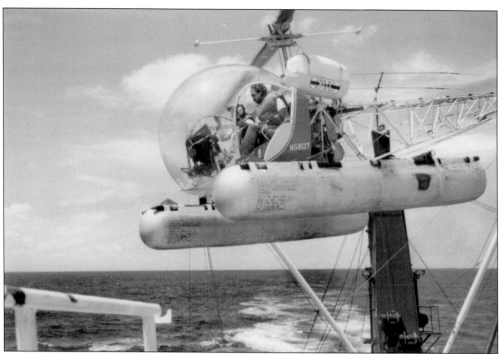

Just as the shipbuilding industry has modernized, so too have the tools. The introduction of the light helicopter aboard the seiner resulted in a dramatic technological shift in the fishing fleet, bringing more efficiency by scoping out the fish rather than previous techniques used to identify schools. (Courtesy of the Lococo family.)

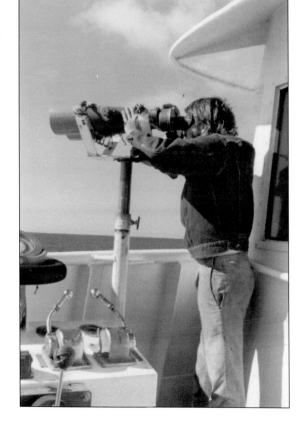

John Lococo, the navigator, spots for fish aboard the *Margaret L*, the family boat, in 1974. As navigator, Lococo divided his time, one half-hour on the scope and one half-hour off, every hour. This was a typical day for the navigator aboard a tuna seiner. (Courtesy of the Lococo family.)

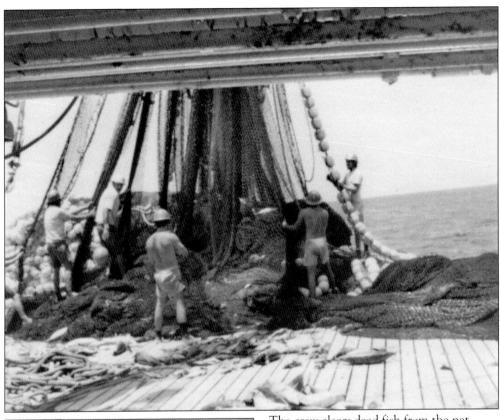

The crew clears dead fish from the net after a big catch on the *Margaret L.* (Courtesy of the Brunetto family.)

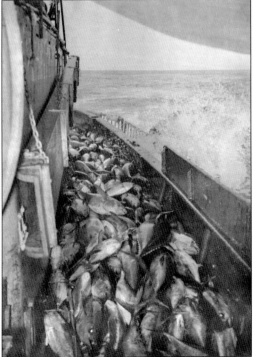

The deck along the bait tank is filled with tuna, indicating a good day of work. (Courtesy of the Crivello family.)

The nets did not always discriminate between tuna and unwanted fish and wildlife. For example, on the *Lou Jean* in 1945, while fishing off the Galapagos Islands, this penguin was inadvertently caught in the bait net and was sent down the chute into the bait receiver. The fishermen found the penguin during the course of draining the tank and were able to rescue it and return it to sea. (Courtesy of the Guidi family.)

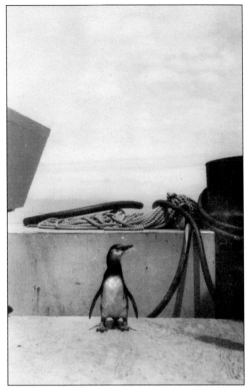

The crew of the *Mary Barbara*, which was one of the first reinforced-concrete ships to be built after the war, is pictured above. The *Mary Barbara* was launched in 1947. (Courtesy of the Tarantino family.)

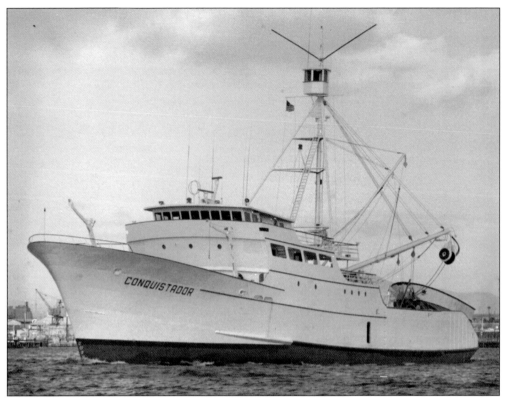

Pictured here is the *Conquistador*, owned by Joe Soares. The steel purse seiner was built in 1971 by Campbell Industries, which was originally founded as Campbell Machine Works in 1906. (Courtesy of the Portuguese Historical Center.)

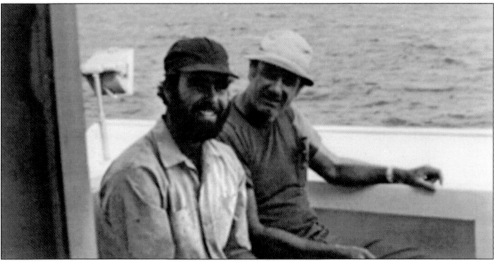

Father and son, Larry and Emilio Piraino, are aboard the Apollo while tuna fishing in Africa in 1972. As shipbuilding and boatbuilding techniques advanced, the fishermen were able to venture much farther from home. In the postwar years, it became common to travel south, to Baja, California, and beyond. In this case, however, a fishing expedition to Africa was also feasible. (Courtesy of the Piraino family.)

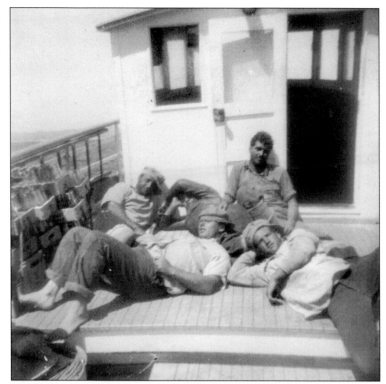

The crew takes it easy after a tough day's work on the *Donna Jo* in 1941. Among the crew is Mike Bono (first row, left). The 63-foot *Donna Jo* was one of San Diego's most productive tuna vessels until it ran aground in foggy weather in 1947 and was destroyed by the surf. All eight crew members aboard at the time were rescued. (Courtesy of Marie Bono Sohl.)

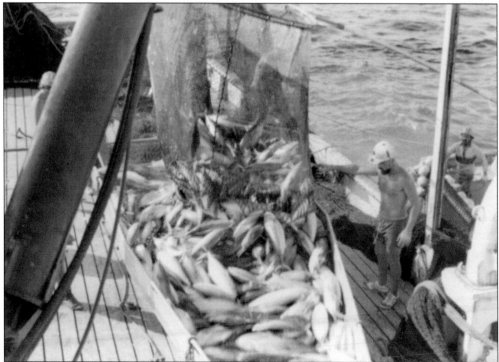

John Brunetto brails into the hopper on the *Margaret L* in 1976. (Courtesy of the Brunetto family.)

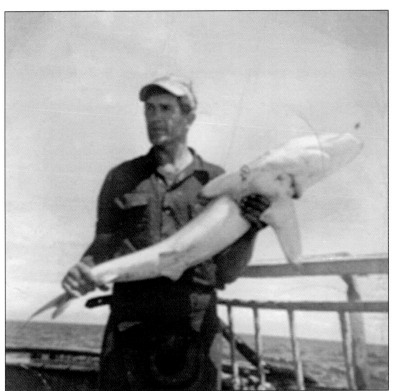

Walter Kamfonik, of Ukranian descent, began a fishing career that spanned more than 30 years after serving in the navy during World War II. In addition to actually hauling in the fish, crew members assumed a variety of roles on the boat. In this case, Walter served as an engineer and oiler for the boats on which he fished. Here he is pictured with a small shark in the 1950s. (Courtesy of the Kamfonik family.)

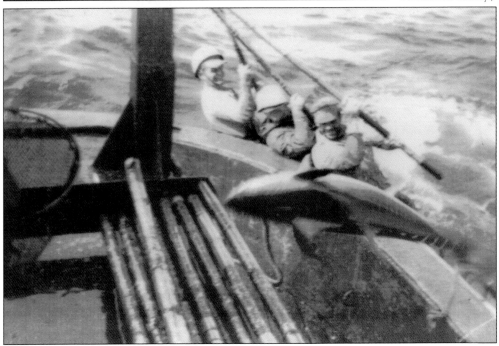

The crew practices three-pole fishing, hauling a large tuna onto the deck. Note the bamboo poles stacked in the foreground, waiting and ready for another catch. (Courtesy of the Tarantino family.)

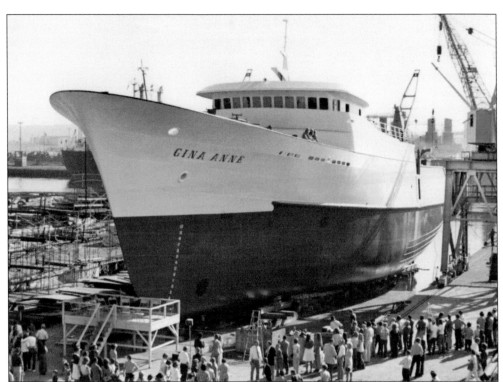

The *Gina Anne*, one of the second generation of purse seiners, sits majestically in port in the early 1970s. (Courtesy of the Portuguese Historical Center.)

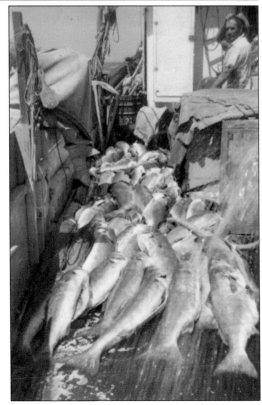

The crew clears the deck, rinsing the fish before sending it into the chute. (Courtesy of Mario Ghio.)

The *North America*, a baby-tuna clipper owned by Agostino Ghio, launched from San Pedro in July 1941. Ghio's son, Fortunato, became its first skipper. The *North America* was ordered to patrol coastal waters at the beginning of World War II. It was released by the U.S. government in March 1942 to recommence tuna fishing. (Courtesy of James Bregante.)

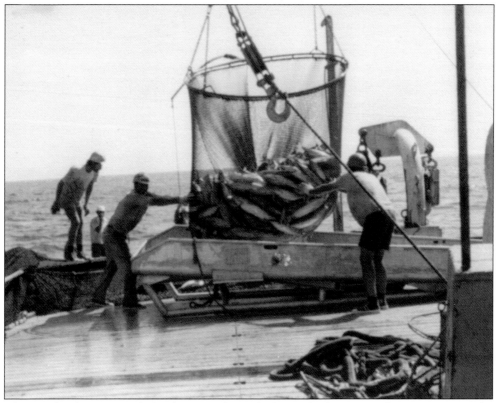

The crew brails tuna caught by the one-pole method into the hopper on the *Margaret L* in the mid-1970s. (Courtesy of the Brunetto family.)

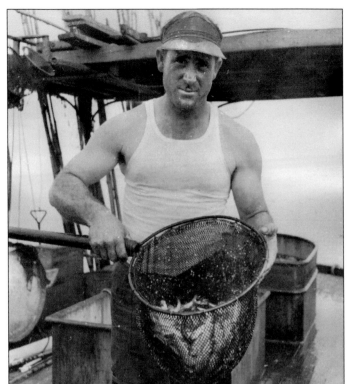

In the photograph at right, Sam Crivello holds his bait net full of sardines. In the photograph below, Sam holds a sextant to find the boat's bearings and lead the crew to the best fishing grounds. (Courtesy of the Crivello family.)

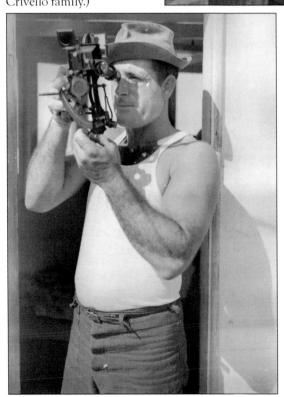

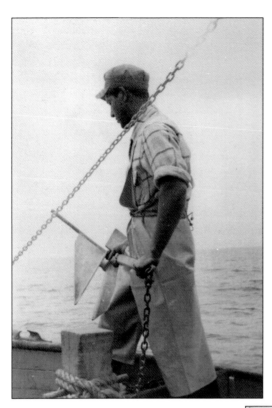

Vince Tarantino prepares to drop the anchor from the *Carmela* in the late 1940s. (Courtesy of the Tarantino family.)

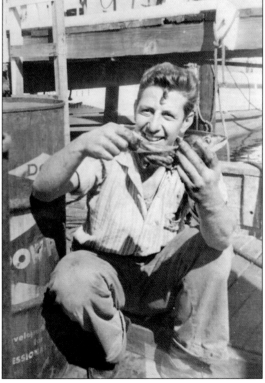

John Mangiapane, who remains a fisherman today, prepares the bait for his pole aboard the *Maria Jo* in 1962. Built in 1939, the *Maria Jo* was originally owned by a Portuguese fishing family and was used primarily to fish swordfish. In fact, the boat holds the record for the largest swordfish ever caught—weighing 900 pounds—off the coast of Mexico. (Courtesy of John Mangiapane.)

When the men return from fishing, the work does not end. The crew repairs the large purse seine and prepares it for the next trip. Frank Balistreri (far left) stands next to his cousin Stefano Balistreri in 1960. (Courtesy of Rosemarie Balistreri, daughter of Frank and Angeline Balistreri.)

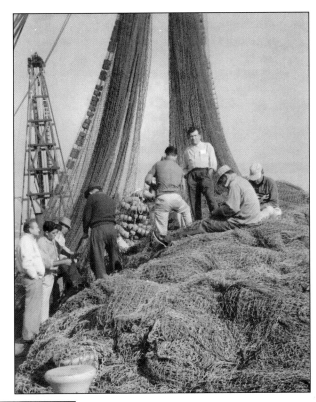

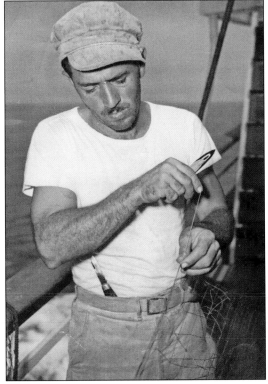

The crew mends nets on the *Coronado* around 1952. Like so many immigrant families, the Zottolo family, hailing from the Sicilian village of Mazzara del Vallo, came to San Diego for the fishing. (Courtesy of the Zottolo family.)

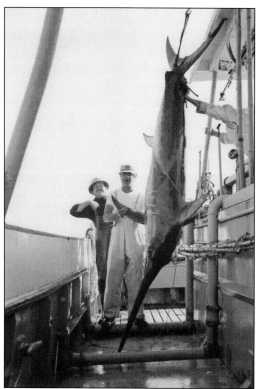

The techniques varied depending on the catch. Here Capt. Joe Tarantino and Hector Mayoral pose with their catch, a 400-pound swordfish, harpooned by the crew off the coast of Monterey Bay while aboard the *Westerly* in 1977. (Courtesy of the Tarantino family.)

The bait boat *Invader*, owned by the Navarra-Vattuone family, floats on San Diego Bay. (Courtesy of the Massa, Castagnola, Navarra, and Vattuone families.)

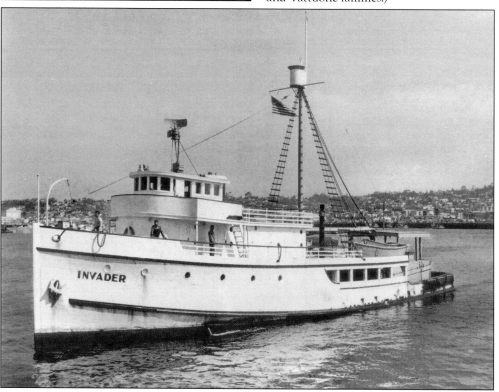

Tuna was certainly the most lucrative catch for selling at the market and for canning, but smaller fish, such as sardine and mackerel, also made the San Diego fishing industry what it was. Lighter lampara boats dominated the sardine industry in particular in the late 1920s. In later years, as this 1940s photograph shows, the crew fishes for sardines to be used as bait for tuna. (Courtesy of the Crivello family.)

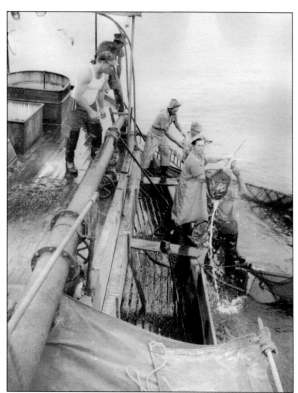

The *Westerly* fishes off Cabo San Lucas, Mexico, in 1978 with a diverse crew. In the racks from left to right are Pietro Tarantino, Bobby Oliver, Hector Mayoral, Anthony Tarantino, and Capt. Joe Tarantino. Pete Tarantino is the chummer standing above on the box throwing bait to lure the tuna. (Courtesy of the Tarantino family.)

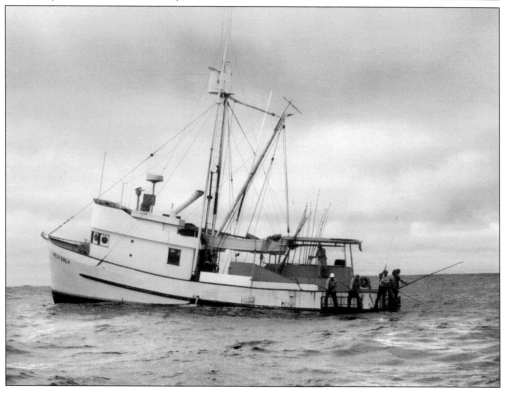

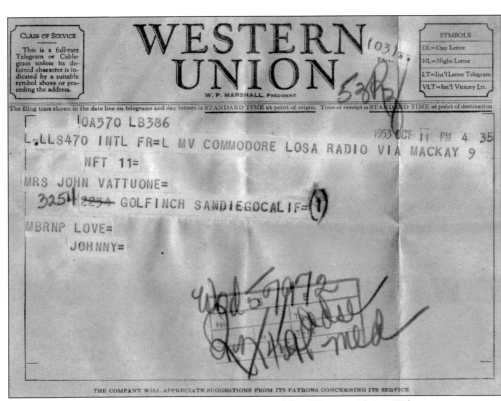

WESTERN UNION

W. P. MARSHALL, PRESIDENT

CLASS OF SERVICE

This is a full-rate Telegram or Cablegram unless its deferred character is indicated by a suitable symbol above or preceding the address.

SYMBOLS

DL=Day Letter
NL=Night Letter
LT=Int'l Letter Telegram
VLT=Int'l Victory Ltr.

The filing time shown in the date line on telegrams and day letters is STANDARD TIME at point of origin. Time of receipt is STANDARD TIME at point of destination

10A570 LB386

L.LLS470 INTL FR=L MV COMMODORE LOSA RADIO VIA MACKAY 9

1953 OCT 11 PM 4 35

NFT 11=

MRS JOHN VATTUONE=

3254 2254 GOLFINCH SANDIEGOCALIF=①

MBRNP LOVE=

JOHNNY=

THE COMPANY WILL APPRECIATE SUGGESTIONS FROM ITS PATRONS CONCERNING ITS SERVICE

A. - We are at Galapagoes Island.
G. - Fish are not biting.
Y. - Fish are biting slow.
S. - Fish are biting fair.
P. - Plenty of fish, but don't bite.
Z. - We have a half load aboard.
N. - Very little fish aboard.
M. - We are almost loaded.
B. - Expect to leave for home soon.
O. - We are all feeling fine and hope the same of our families.
T. - Not quite a full load.
L. - We are on way home with full load.
C. - There is no fish here.
R. - We are going to the coast fish reported there.
D. - We are on the coast.
E. - We are doing fair.
F. - We expect to arrive in San Diego tomorrow.
H. - We are going to Point Arena, you may write.
I. - We are going to Panama for bait.
J. - Miss you very much honey love and kisses.
K. - Tell our families hello for us.
Q. - How are our families?
U. - We arrived at Galapagoes yesterday, and are now looking for bait.
V. - Bait is very scarce.
W. - Weather is fine.
X. - We are fishing local.
MM - Coming home with not a full load.

This Western Union Telegram demonstrates how sister ships would rely on codes to communicate with one another so as not to divulge their bearings, and thus the good fishing, to competition on the seas, as well as to send news to shore. In this case, a telegram from John Vattuone to his wife relies on code sent from the MV *Commodore* in 1953 to relay information about the fishing conditions and his return home. (Courtesy of the Castagnola and Vattuone families.)

Joseph Tarantino stands (second from left) in the racks fishing for bait in the mid-1950s off the coast of Panama. The coastline along Peru was a common fishing spot for tuna when the tuna in San Diego waters became scarce. (Courtesy of the Joseph Tarantino family.)

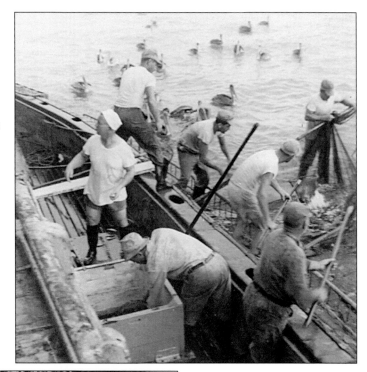

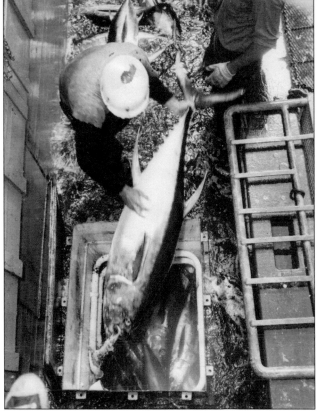

This image captures yet one more step in the process of catching tuna. After catching the fish and hauling it aboard, the crew stacks them in a holding tank, or well. Here Joe Lucas makes room for a big one around 1949. (Courtesy of the Portuguese Historical Center.)

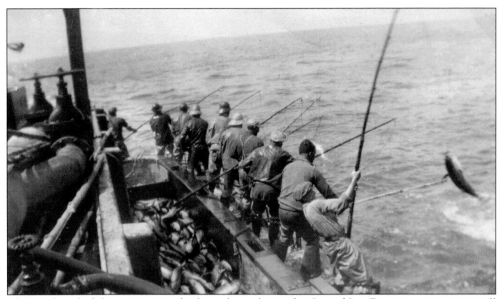

The single-pole fishing crew stands along the racks on the *City of San Francisco*, waiting to pull in the tuna off the coast of Mexico in 1932. (Courtesy of the Zottolo family.)

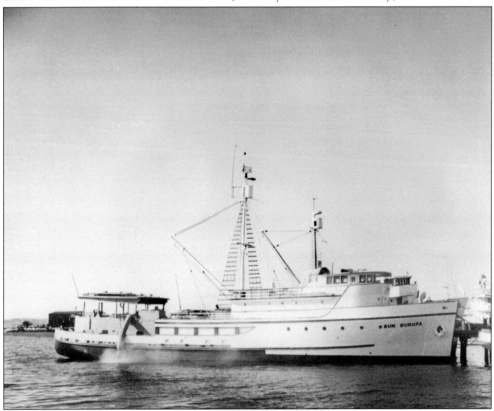

The *Sun Europa* sits regally at dock around 1955. The boat belonged to the Crivello family, a prominent fishing family in San Diego. The *Sun Europa* was the third of their family boats, preceded by the *Europa* and the *Sun Harbor*. (Courtesy of the Crivello family.)

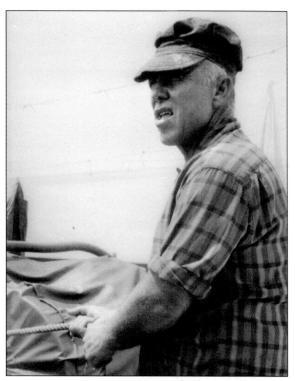

Louis Castagnola, fondly known in the tuna community as "Uncle Louie," was a tuna-fishing pioneer. His career lasted 45 years, serving as crew member, captain, boat owner, and manager. Over the course of his career, he was directly responsible for the rescue of 29 lives at sea, as well as saving another vessel. He was president of the American Tunaboat Association in 1970 and remained on its board of directors thereafter. Here he is pictured with his namesake vessel. (Courtesy of the Castagnola family.)

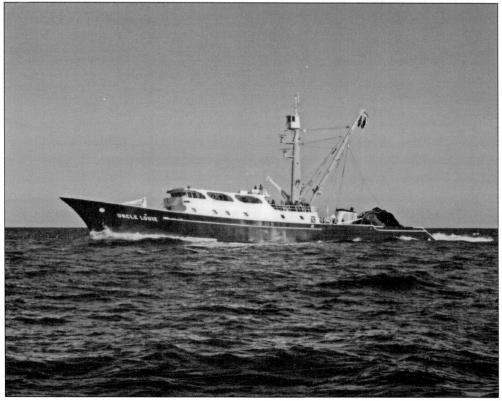

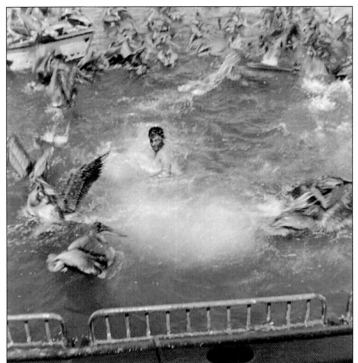

Fishing is for the birds! On most occasions, the presence of sea birds was a good indication of plentiful fishing grounds, and thus good fishing. In this case, however, a crew member is overrun with pelicans, making for an adventurous day of fishing. (Courtesy of the Joseph Tarantino family.)

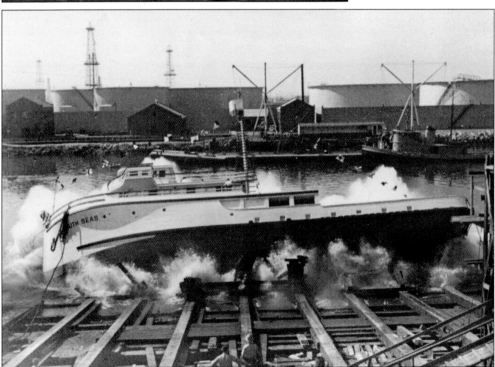

The *South Seas* is launched into the San Diego Bay around 1940. Launching typically was done in one of three ways: straight launch by sliders off the ways; the side launch, as shown here; or a sea launch. (Courtesy of the Portuguese Historical Center.)

The men continue to fish off the racks, filling the alleyway with tuna. Once the alleyway is full, it becomes necessary to move the catch forward, a task part of the crew works to do by lifting the fish into the holding tank. (Courtesy of the Zottolo family.)

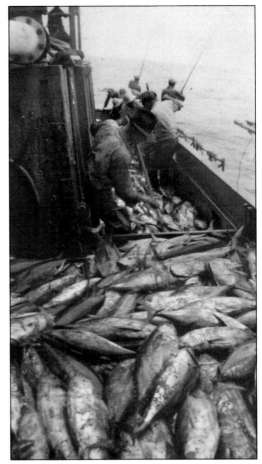

A bait boat, also named the *South Seas*, owned by Steve Stagnaro and his nephews fishes off the coast of Mexico around 1955. Andy Stagnaro was the navigator, and John Zuanich was the skipper. (Courtesy of the Stagnaro family.)

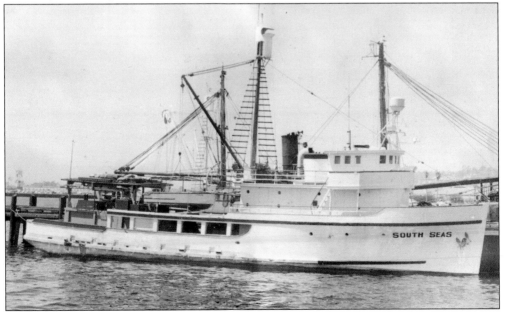

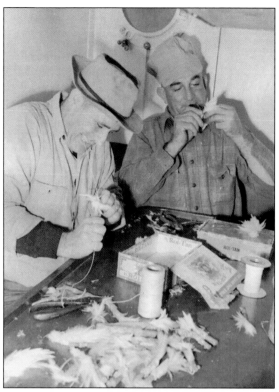

Two members of the *Sun Harbor* work from their makeshift bait-and-tackle cigar boxes to create the tuna lures, or "squids," by stuffing white feathers into a brass fitting filled with lead. (Courtesy of the Crivello family.)

The *Sun Harbor* carries its crew in the mid-1940s. (Courtesy of the Crivello family.)

Frank Principato rests on the bait tank of the *Carmela* in the late 1940s; the bamboo poles stand to this right. (Courtesy of the Tarantino family.)

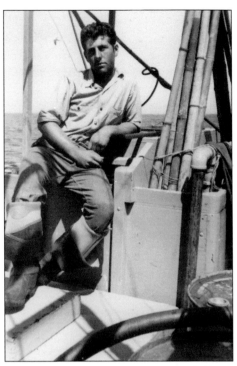

The crew aboard the tuna clipper scoops—or brails—bait out of the net, holding broomsticks to keep the skiff out of the way, while other crew members stack the net. Note that small-sized corks line the seine; they will be replaced by larger-sized corks in later generations of the purse seiner. (Courtesy of the Portuguese Historical Center.)

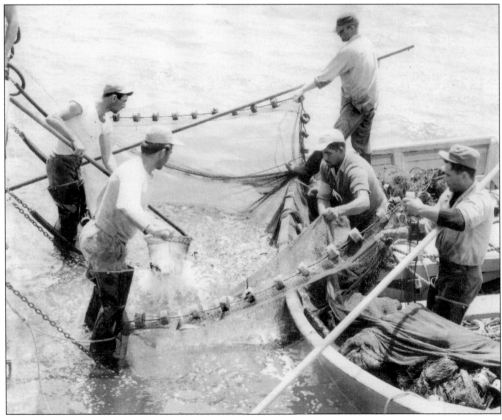

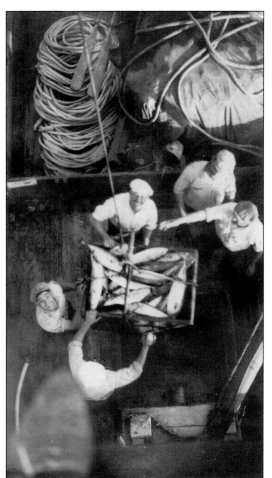

Shortly after docking, the *White Star* and its crew unload in 1939. Joe Zottolo (left) looks up to the camera with a broad smile, as he and the rest of the crew lift the hopper filled with tuna. (Courtesy of the Zottolo family.)

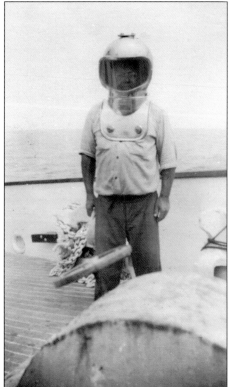

A crew member aboard the *American Voyager* dons a diving helmet to clear the bait net from underwater obstructions around 1940. (Courtesy of Andrew Asaro.)

The crew gets into their work. The fishermen labor to clear the alleyway of fish by loading them into the tanks. (Courtesy of the Crivello family.)

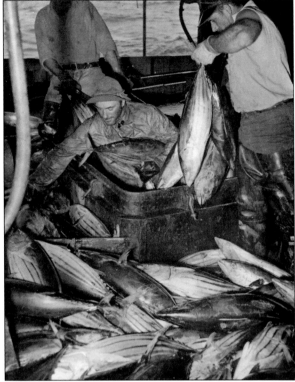

This c. 1980 photograph of the *Jeannine*, owned by Zolezzi Enterprises, was taken in Samoa. Samoa became a popular fishing spot in the last decades of the 20th century. The skipper was John Canepa, who served as a captain in the San Diego fishing industry for 12 years. (Courtesy of John Canepa.)

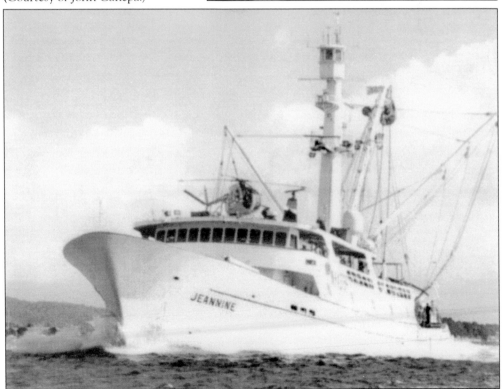

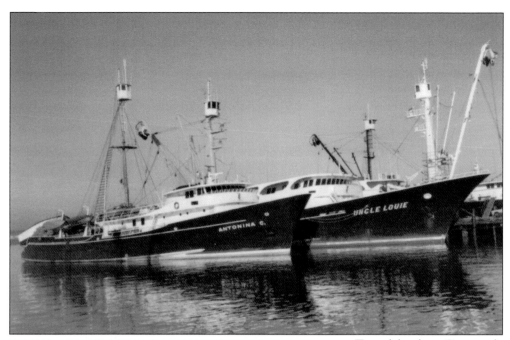

Two of the three Castagnola family boats are pictured here: the *Antonina C* (built in 1970) and the *Uncle Louie* (built in 1978). The *Andrea C* (not pictured) was built in 1981 to honor the patriarch, Andrea, a major contributor to San Diego's fishing industry. (Courtesy of Mr. and Mrs. Louis Castagnola and sons.)

The *Margaret L*, named after Margaret Lococo, was built in 1972. Owned by Andrew Lococo, the boat sank in 1976 off the coast of Costa Rica due to an engine fire. The crew was rescued by the *Marjorie R*; 20 crew members sat in a skiff for hours awaiting rescue. It was the largest seiner to date—with the capacity to carry 2,200 tons—fishing for yellowfin and skipjack tuna. (Courtesy of the Lococo family.)

The fish were flying on this successful day of fishing on the *American Voyager* in 1940. (Courtesy of Andrew Asaro.)

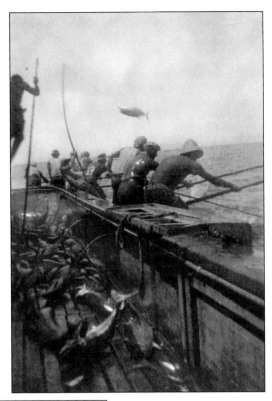

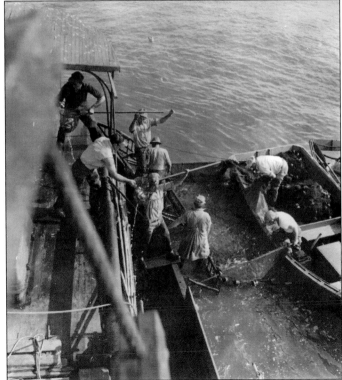

This image on the *Sun Harbor* captures the many steps that are part of the sequential process of fishing while aboard the boat. These stages will, of course, be followed by yet more steps once the crew arrives ashore, as chapter four illustrates. (Courtesy of the Crivello family.)

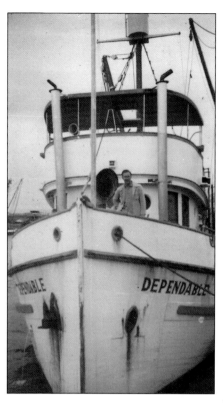

This photograph shows the *Dependable*, owned by Francesco Alioto. The Alioto family came to San Diego via San Francisco in 1939. (Courtesy of the Stephen Zolezzi family and the Francesco Alioto family.)

Stephen Zolezzi, who was a fisherman in San Diego for more than 50 years, is shown on the *Marie Louise* around 1930. (Courtesy of the Stephen Zolezzi family and the Francesco Alioto family.)

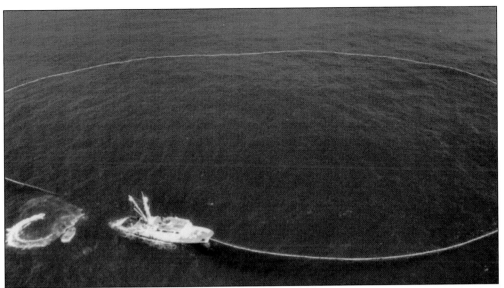

The MV *Jeannine* makes set with the large purse seine net, which is approximately one-quarter of a mile in diameter. They are fishing for tuna in the eastern Pacific Ocean around 1980. (Courtesy of John Canepa.)

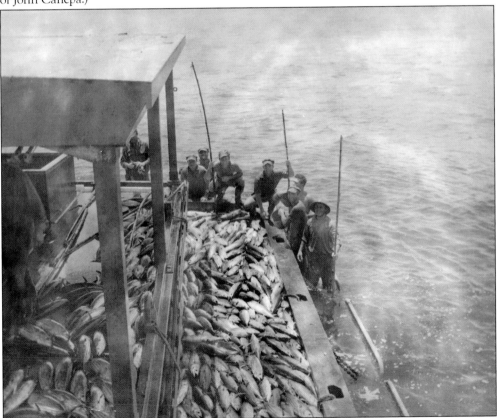

The crew pauses to pose for a photograph, boastfully presenting, with a sense of satisfaction, the bountiful harvest. (Courtesy of Mr. and Mrs. Louis Castagnola and sons.)

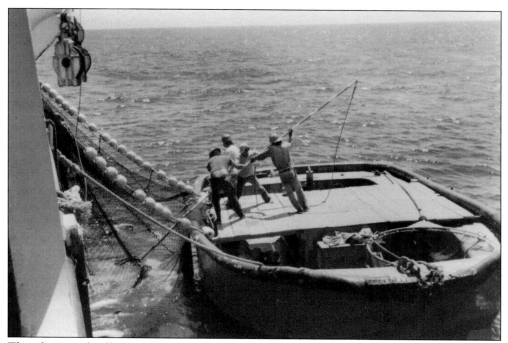

This photograph offers another view of the brailing process aboard the *Margaret L* in 1974. The skiff rides "piggyback" to the boat to assist in the process of closing the net and bringing the fish aboard the larger vessel. (Courtesy of the Lococo family.)

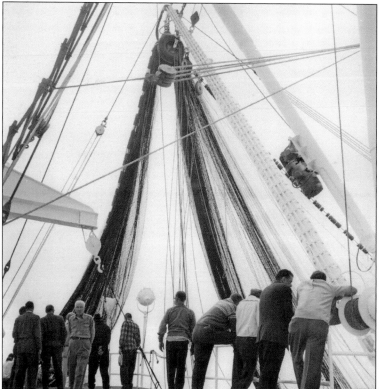

A group of visitors, likely including the boat owners themselves, tour a modern purse seiner prior to its trial run. The seine towers above. (Courtesy of the Portuguese Historical Center.)

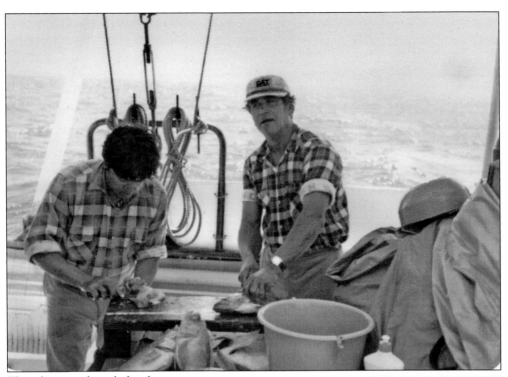

This photograph includes the "chummer" Pete Tarantino and Capt. Joe Tarantino on the *Westerly* around 1976, off of Santa Cruz, California. The men clean rock fish in preparation for dinner. (Courtesy of the Tarantino family.)

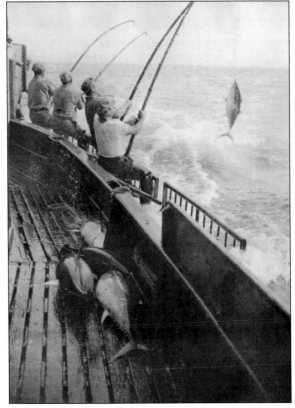

These men are two-pole fishing on the *Sun Harbor* in the mid-1940s. (Courtesy of the Crivello family.)

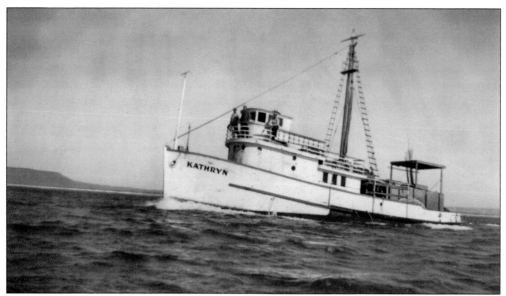

The majestic bait boat *Kathryn*, owned by the Guidi family, coasts along around 1939. (Courtesy of the Guidi family.)

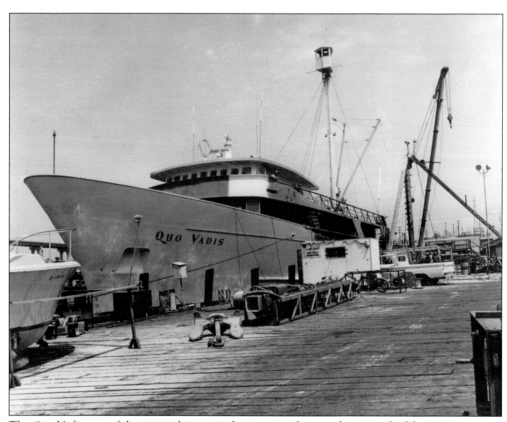

The *Quo Vadis*, one of the original converted purse seine boats, is being readied for its next voyage out to sea around 1960. (Courtesy of the Portuguese Historical Center.)

Four

COMING ASHORE
LIFE ON THE DOCKS

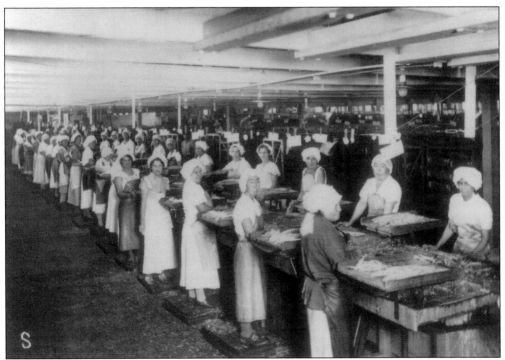

Women of various ethnic and social backgrounds found jobs in the San Diego canneries while the men were out fishing. These women are working at Westgate Cannery. In the 1930s, Luisa Moreno, a Hispanic labor activist, fought for reform in the San Diego canneries, eventually organizing unions in the tuna industry. At that time, many Latinos who were living in Barrio Logan and Boyle Heights found employment in tuna packing. The cannery workers toiled around the clock in what Moreno deemed to be sweatshop conditions. She became the international representative of the United Cannery Agricultural Packing and Allied Workers of America in 1938. (Courtesy of the Maritime Museum of San Diego.)

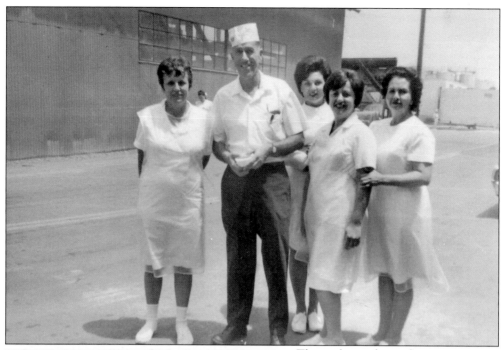

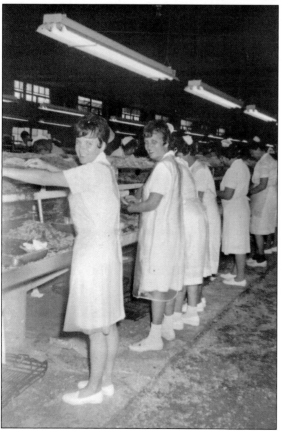

The packing of tuna for mass consumption began in Southern California in the first decade of the 20th century. Dubbed "chicken of the sea" by the packing company of the same name and recognized as such by American consumers nationwide in the 1920s and 1930s, there was no market for canned tuna in any other country except the United States until after World War II. Above, Josephine Alioto (far left) stands with her coworkers outside the Westgate Cannery around 1965. At left, Leonilda Stagnaro Wilson (far left), Josephine Alioto (second from left), and coworkers labor along the assembly line at the cannery. (Courtesy of Frank and Bianca Alioto and family.)

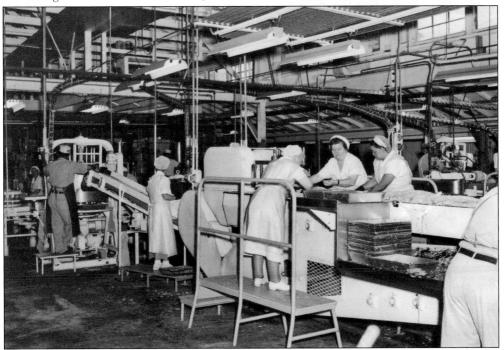

As early as 1901, the Pacific Fishing and Exploration Company announced its plans to establish a cannery for sardine packing and to prepare dry fish for export to China. The first case of albacore was packed in 1905 by H. Halfhill in San Pedro, California. By 1923, there were nine tuna-packing companies in San Diego. Pictured at right is Dena Castagnola with the foreman from the Del Monte Cannery, parent company to Starkist Tuna, in 1937. Below, Dena is pictured working in a cannery in 1954. (Courtesy of the Castagnola and Vattuone families.)

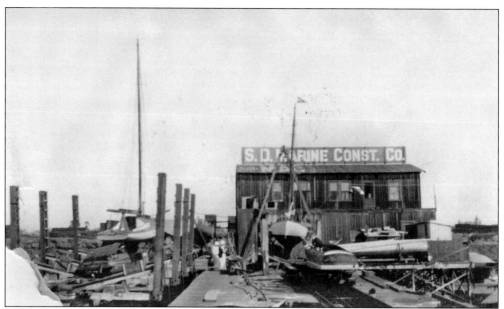

This image captures San Diego Marine Construction Company, one of the first shipbuilding companies in San Diego. (Courtesy of the Portuguese Historical Center.)

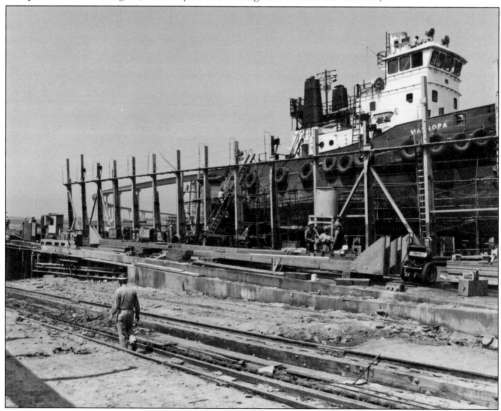

Shipbuilding in San Diego was a lucrative business by 1930. (Courtesy of the Portuguese Historical Center.)

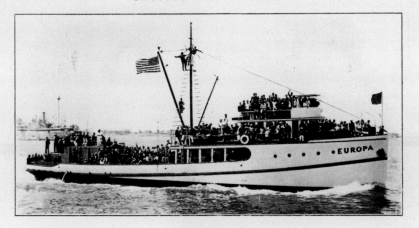
A 1931 advertisement for Union Diesel Engine Company from *Pacific Motor Boat* magazine highlights the building of the *Europa*. It was constructed for the Crivello family by Campbell Machine Company, which later became known as Campbell Industries. (Courtesy of the Crivello family.)

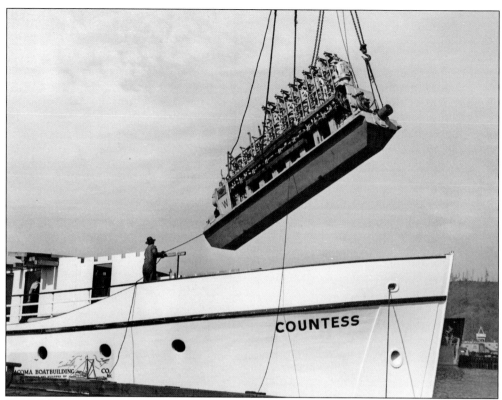

One of the more precarious steps involved in shipbuilding is the process of lowering the engine into the boat without damaging the hull. In this photograph, taken at the shipyards at the Tacoma Boat Building Company in Washington, a crane lifts the engine into the ship. (Courtesy of the Portuguese Historical Center.)

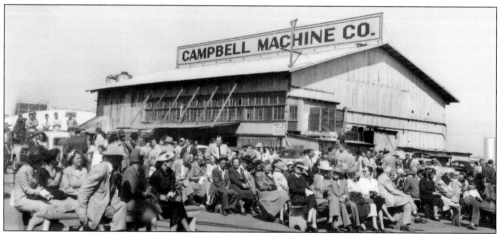

George E. Campbell and his brother Dave founded a family-owned machine shop in 1906 that became one of the more successful shipbuilding companies, Campbell Industries, in San Diego. The brothers' company built some of the largest tuna boats in San Diego during the 1920s and 1930s, and is credited for the development of on-board refrigeration systems, which resulted in the advancement of the fishing industry, but was also an important factor in the navy's selection of boats for requisitioning during World War II. (Courtesy of the Portuguese Historical Center.)

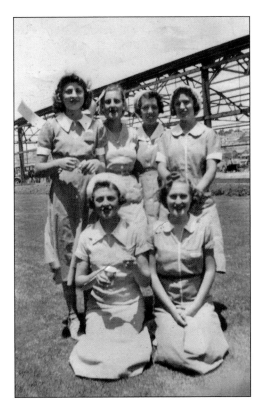

Pictured at right, Rose Alioto (second row, second from right) stands with coworkers at the Del Monte Cannery. Rose is also pictured below, second from right. (Courtesy of the Stephen Zolezzi family and the Francesco Alioto family.)

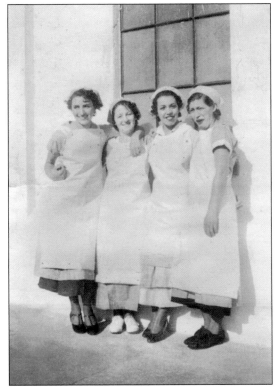

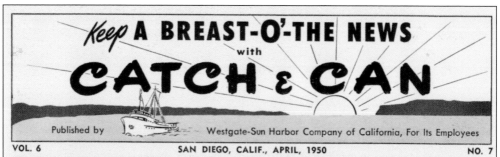

Keep A BREAST-O'-THE NEWS
with
CATCH & CAN

Published by — Westgate-Sun Harbor Company of California, For Its Employees

VOL. 6 SAN DIEGO, CALIF., APRIL, 1950 NO. 7

FAMILIAR "BREAST-O'-CHICKEN" SIGN INSTALLED ON ROOF

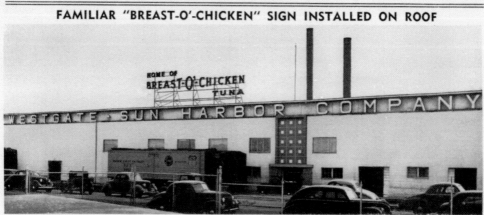

One of San Diego's most familiar landmarks for many years, the "Breast-O'-Chicken" sign which served as a beacon atop the old Westgate Sea Products Co. cannery off Pacific Highway, has been installed on the roof of the Westgate-Sun Harbor Company. For many a visitor to San Diego, and local residents returning home, sight of the sign on the Westgate plant was welcome indication that they were nearing their destination.

"Santa Barbara" Released From Tieup At Galapagos

A four days' tieup at Seymour Island in the Galapagos group was experienced l a s t month by the Westgate-Sun Harbor clipper Santa Barbara.

The vessel was ordered detained by the island's commandant in a misunderstanding over fishing regulations.

Permits issued by the San Diego Ecuadorean consul are good for 90 days fishing, under a November, 1948 amendment to the fishing rules of Ecuador, which owns the islands.

But the commandant was under the impression that the old 45-day maximum was still in effect. The Santa Barbara had been in Galapagos waters more than 45, but less than 90 days.

Dr. Bolivar Oquendo, Ecuador consul in San Diego, sent two urgent messages to the commandant and to the government capital in Quito, Ecuador, which finally led to release of the Santa Barbara.

The detention made it impossible (Continued on Page 2)

HOW LONG WILL YOUR JOB LAST?

Once a year, usually about this time, some of America's most important publications come off the presses. They are the Annual Reports of business.

An Annual report is exactly what it says — a *report*: a responsible public statement on what the business has done in the year past, and what its hopes and prospects are for the future.

All money earned and spent by the business is openly accounted for. The report shows what sums of money have gone for wages and worker benefits, for materials, for research, taxes, rents and other cost items. It records profits, and the way in which profits have been put to work.

Not every Annual Report is a record of financial success. Actually, only one-half of all 450,000 U. S. corporations show a profit in any given year.

How long will your job last? Though the Annual Report does not say so in so many words, the answer is plain: your job depends on (1) whether your company continues to make a substantial profit, and (2) whether you recognize as a part of your daily work a personal responsibility to help it make such a profit.

Westgate-Sun Harbor Buys Monterey Sardine Cannery

Westgate-Sun Harbor Co., already one of the largest in the nation in tuna packing, diversified its holdings last month by purchase of the old Sun Harbor Packing Co's sardine cannery in Monterey.

In the original merger of the Westgate and Sun Harbor companies Jan. 1, Sun Harbor's Monterey plant was not included.

A $100,000 modernization program has been launched at Monterey following the most successful canning year in that plant's history since Sun Harbor acquired it in 1946. The plant's capacity will be considerably enlarged.

Being installed are 3 automatic packing machines for one-pound cans; 2 new exhaust boxes, one for oval cans and one for tall cans; and a new cutting machine.

Five existing cutting machines are being revamped, and an exhaust box is being converted from use for tall cans to oval cans. Numerous other changes are being (Continued on Page 2)

The April 1950 issue of the popular monthly newsletter *Catch and Can* highlights news and events from the Westgate–Sun Harbor Canning Company, keeping employees abreast of relevant news in the industry. (Courtesy of the Tarantino family.)

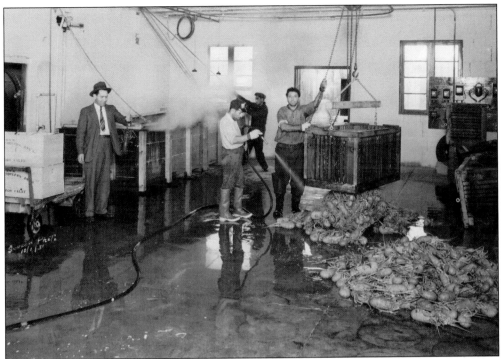

The canneries and packing companies provided employment for many San Diegan men and women. In the photograph above, men unload lobster at a packing company in 1931. In the image below, workers gut tuna to prepare it for the assembly line cannery around 1940. (Courtesy of the Maritime Museum of San Diego.)

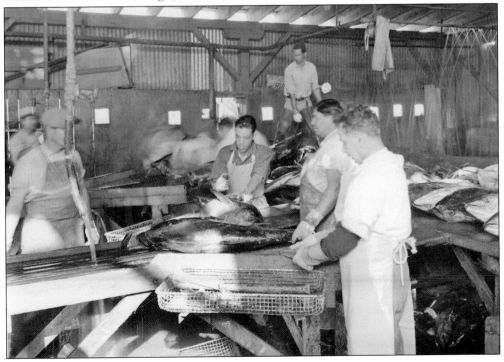

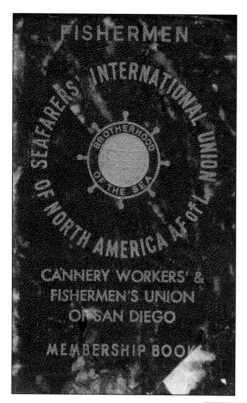

Pictured at left is the cover from the *Cannery Workers and Fishermen's Union of San Diego* membership book. The book was owned by Walter Kamfonik, who joined the union in 1949. (Courtesy of the Kamfonik family.)

CANNERY WORKERS AND FISHERMEN'S UNION
OF THE PACIFIC

No. 570-H

CERTIFICATE OF MEMBERSHIP

Name *Walter Kamfonik*

This CERTIFICATE, when properly signed and sealed with the Seal of the Seafarers' International Union of North America, is evidence of the fact that the bearer, if corresponding to description here annexed, is a full member of the

SEAFARERS' INTERNATIONAL UNION (of North America)

and entitled to due faith, confidence, credit and assistance from all members and all or any of the Workingmen of the World.

George Feduma
President, Local Union

Lester Balinger
Secretary, Local Union

Paul Hall
President, S.I.U. of N.A.

PERSONAL DESCRIPTION

Photo

Born *Mass.* Date *6/23/21*
Color eyes *Blue* Hair *Brown*
Weight *200* Height *6'2"*
Citizen *yes* Place *San Diego*
Joined *4/20/49* Soc. Sec *036-07-9768*

Walter Kamfonik
Member's Signature

106

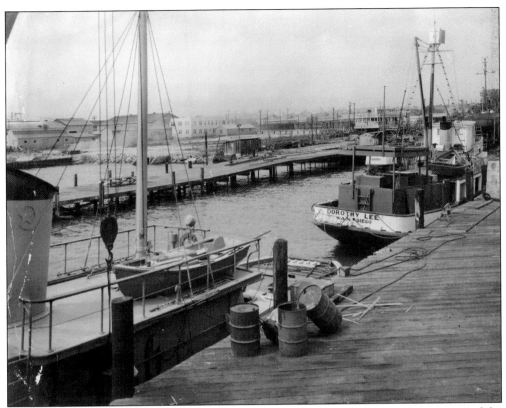

The *Dorothy Lee* sits at the San Diego wharf with the city in the background. (Courtesy of the Portuguese Historical Center.)

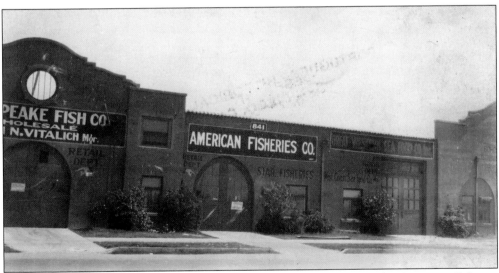

This photograph captures two of the earliest fish markets in San Diego: the American Fisheries Company and the Chesapeake Fish Company. In addition to canning, fresh fish were sold at wholesale and retail markets. In this case, the fish were unloaded directly off the boat and delivered to the respective markets. (Courtesy of the Portuguese Historical Center.)

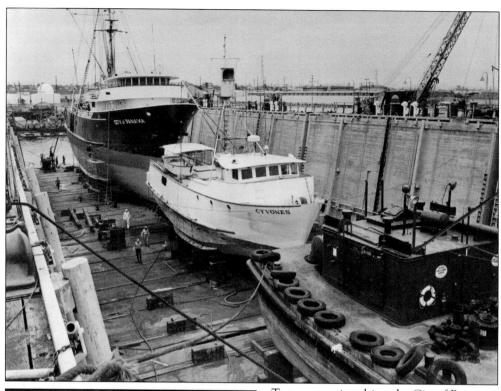

Two contrasting ships, the *City of Panama* and the *Cyvones*, sit in line with one another for repair on the docks. (Courtesy of the Portuguese Historical Center.)

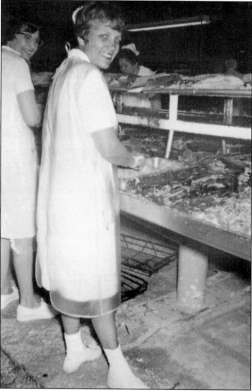

Antoinette Giacalone (left) and Josephine Alioto take a quick break from work at Westgate Cannery to pose for a photograph. (Courtesy of Frank and Bianca Alioto and family.)

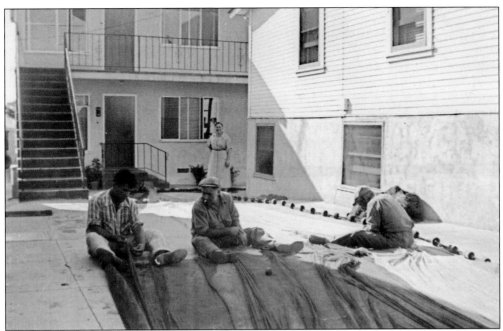

In the photograph above, a family mends the bait net, or lampara, for the boat *Carmela*. Pictured in 1950 are (from left to right) John Tarantino, Giovanni Tarantino, and unidenfited; Nina Valenti stands in the back. The photograph was taken in the yard of the Tarantino residence on India Street in Little Italy. The image below captures the view looking from the house toward India Street featuring what was then called the Roma Inn, where Filippi's Pizza Grotto stands today. (Courtesy of the Tarantino family.)

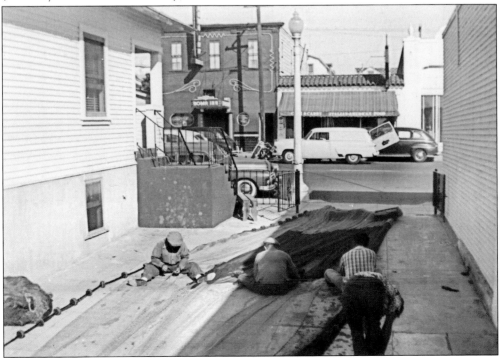

The National Steel and Shipbuilding Company began as a small machine shop and foundry known as California Iron Works in 1905. In 1922, California Iron Works was taken over by U.S. National Bank and renamed National Iron Works. Eleven years later, C. Arnholt Smith acquired the company. During the war, National Iron Works moved to Twenty-eighth Street and Harbor Drive. In 1949, the company was renamed the National Steel and Shipbuilding Company (NASSCO) to reflect expansion into ship construction. The company built the famed *Conte Bianco* in 1951. (Courtesy of Mr. and Mrs. Louis Castagnola and sons.)

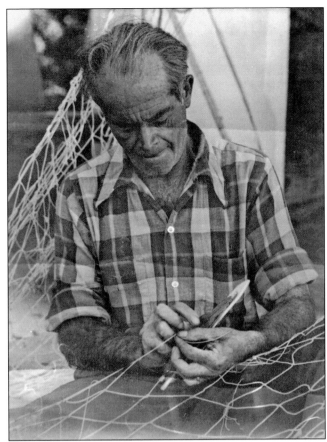

Giuseppe Carini repairs a fishing net at his home. Below, Giuseppe with his sons, Tony and Phil, prepare to fish with gill nets around 1970. (Courtesy of the Carini family.)

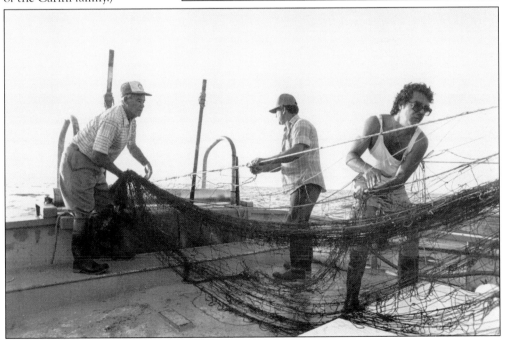

Joe Tarantino oversees the mending of the lampara net in his family's yard in Little Italy. (Courtesy of the Tarantino family.)

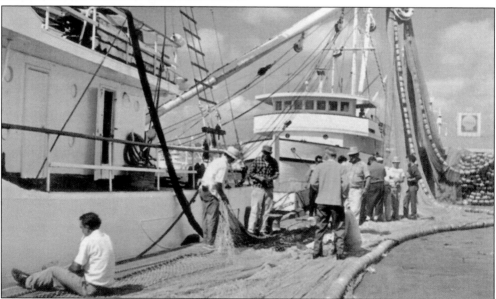

Frank Balistreri repairs nets at the dock in 1960. Having come from Aspra, a small fishing village in Sicily, Balistreri was among the generation of men who were taught to maintain and sew the nets. This ability served them well in later years, as the younger generations born and raised in the United States no longer possess that skill. Boat owners would recruit these skilled men to repair the nets, as Frank is doing in this photograph. (Courtesy of Rosemarie Balistreri, daughter of Frank and Angeline Balistsreri.)

Five

LOOKING DOWNSTREAM
END OF AN ERA

Sponsored by the Portuguese Historical Center and dedicated in 1988, the Tunamen's Memorial recognizes and commemorates the contribution by fishermen in San Diego's tuna industry. The large bronze sculpture by Franco Vianello is located at Shelter Island in San Diego. (Courtesy of the Portuguese Historical Center.)

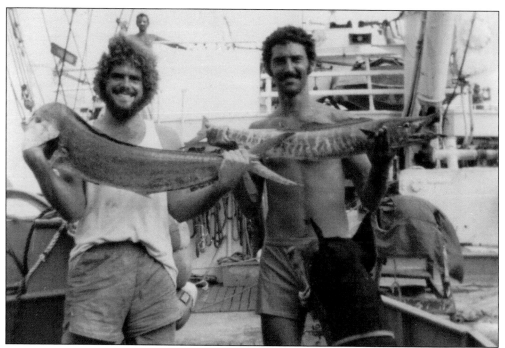

Fishing on the MV *J. M. Martinac* off the coast of Costa Rica, Sal Corona (right), who fished for eight years on both bait boats and seiners, holds a wahoo fish while Vince Hamm holds a dorado fish. Donald Souza was the skipper. (Courtesy of Sal Corona.)

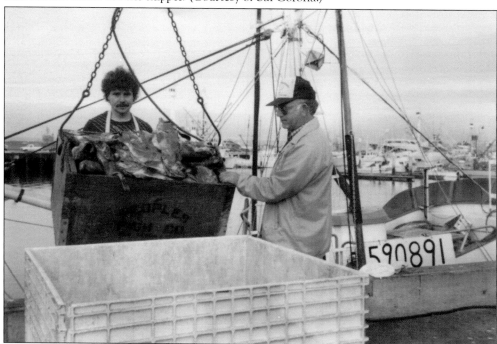

Frank D'Amato stands in front of black gill fish next to Carlos Sanfilippo around 1984. The catch is being unloaded for retail fish markets in San Diego, including People's Fish Company, the Chesapeake Fish Company, and Anthony's Fish Company. (Courtesy of the D'Amato family.)

In this educational piece, "The Tuna Clipper Cares," the significance of environmental concerns regarding the capture and killing of dolphin while purse seine tuna fishing in the 1970s and 1980s is evident. Tuna fishermen are encouraged to care about the dolphin problem and respond to government policies. (Courtesy of Mr. and Mrs. Louis Castagnola and sons.)

THE CAPTAIN CARES...

THE TUNA CLIPPER CAPTAIN CARES...

about the men
who fish with him
on long trips
over distant seas.

He cares...
about catching tunas
to meet the needs
of all Americans
for good foods.

He cares...
about the porpoise
occasionally trapped
in nets designed
to capture tunas.

Yes, the captain cares...
about the porpoise
and their safety
the record shows
the captain cares.

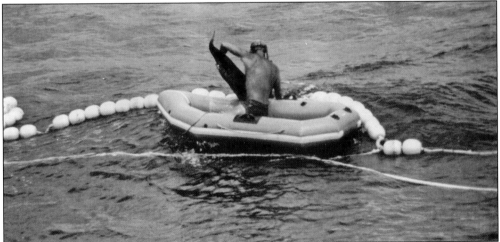

Tuna seiners took early action to reduce dolphin mortalities. In 1957, tuna seiners changed their procedures to back down vessels, so as to release dolphins over the top of the purse seine net. In 1971, San Diego tuna pioneer Harold Medina developed and introduced a special panel for seine nets that further reduced dolphin entanglement. These two methods were improved further after passage of the Marine Mammal Protection Act in 1972. In this instance, a crewman works to free a dolphin from the purse seine by relying on a one-man raft to keep him afloat within the purse seine itself around 1973. The crew members did so at great risk because sharks were never far away, especially if a dolphin had already been hurt or killed. (Courtesy of the Portuguese Historical Center.)

American Tuna, Inc., is a coalition of six San Diegan albacore fishing families who joined forces in recent years to provide top-quality, "dolphin-free" tuna. The San Diego–based company relies strictly on pole and troll albacore tuna–fishing methods, thus earning the self-defined label as a "sustainable tuna fishery." (Courtesy of American Tuna, Inc.)

The fishing industry today remains a family affair. Shown here are Colton (left) and Wyatt Hawkins, the next generation of fishermen of the family-owned-and-operated American Tuna in San Diego. The Hawkins family owns two fishing vessels: the *Sea Chase* (pictured here), which is owned by Paul and Rita Hawkins; and the *Jody H*, owned by Scott and Jody Hawkins. (Courtesy of American Tuna, Inc.)

This image offers yet another view of the Tunamen's Memorial at Shelter Island. The bronze sculpture weighs 9,000 pounds and stands 21 feet tall from the bottom to the tip of the fishing pole. Its inscription reads: "Tunamen's Memorial honoring those that built an industry and remembering those that departed this Harbor in the Sun and did not return. —Anthony Mascarenhas." In 2008, yet another tuna memorial was dedicated to the tuna fleet that served as YPs and to the 600 San Diegan tuna fishermen who were called to service during World War II. The commemorative sign graces the entrance of Tuna Harbor along Tuna Lane and the Embarcadero. (Courtesy of American Tuna.)

Tunamens Memorial
Point Loma, San Diego

The Unified Port of San Diego, Downtown San Diego.

San Diego's port remains an active point of entry for the city. This is a recent image of the Unified Port District. (Courtesy of American Tuna.)

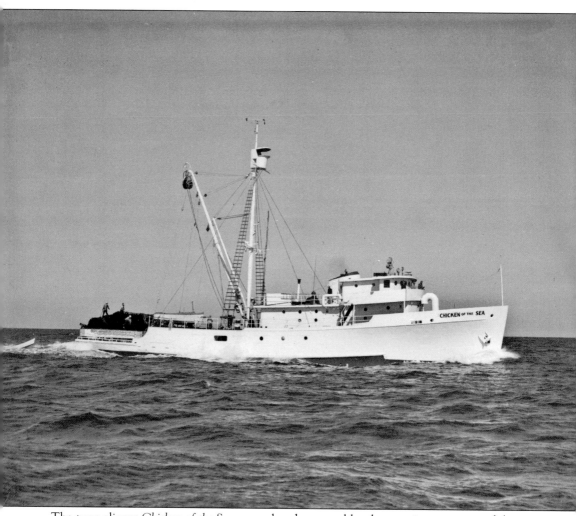

The tuna clipper *Chicken of the Sea*, owned and operated by the canning company of the same name, is representative of the end of an era in San Diego's fishing industry. By 1923, there were nine tuna-packing companies in San Diego. In the post–World War II era, San Diego was called the tuna capital of the world. But beginning in the 1980s, the large tuna canners began leaving California. The last tuna cannery closed its doors in 2001. (Courtesy of the Portuguese Historical Center.)

Fisherman Anthony Madruga is representative of the recent evolution of fishing in San Diego, which now has come to mean smaller boats for retail and sportfishing. The boat pictured here is the *Angelina*. The catch for these smaller-sized boats is often albacore or swordfish. (Courtesy of Anthony Madruga.)

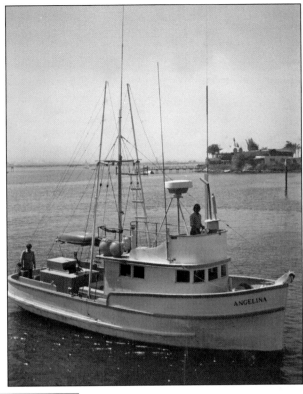

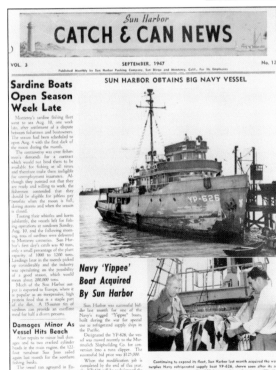

In all, 53 tuna clippers were used by the U.S. Navy to patrol the Pacific Ocean during World War II. By the end of 1942, the tuna fleet's production capacity had dropped to 60 percent of the 1941 production. Twenty-one YPs never returned to be restored as tuna boats. This *Catch and Can* newsletter from Westgate–Sun Harbor cannery, however, details some of the reconversions from YP to tuna clippers in 1947. (Courtesy of the Tarantino family.)

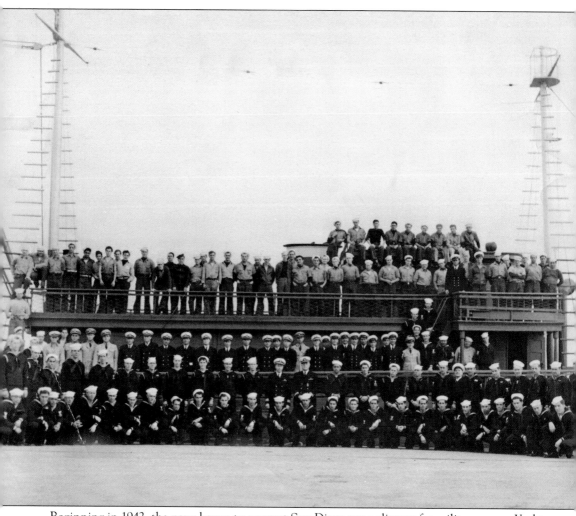

Beginning in 1942, the navy began to convert San Diego tuna clippers for military use as Yacht Patrols, or YPs. The boats were painted grey and given designated YP numbers. In addition, all clippers that were used as YPs were armed with a 20-millimeter cannon and 50-caliber and World War I–era 30-caliber machine guns. The largest of the clippers were also fitted with a 75-millimeter cannon at the bow. In this image, the naval crew of the YP100 poses for a photograph. (Courtesy of the Portuguese Historical Center.)

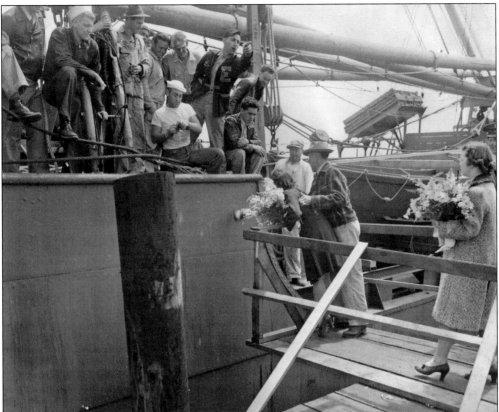

Converted Yacht Patrols were also christened in a formal ceremony before being sent out to defend from submarine attacks during World War II. In this photograph, navy seamen and onlookers celebrate the christening of the YP100. (Courtesy of the Portuguese Historical Center.)

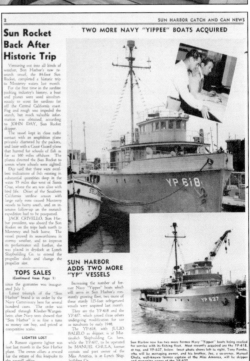

Sun Rocket Back After Historic Trip

TWO MORE NAVY "YIPPEE" BOATS ACQUIRED

Venturing out into all kinds of weather, Sun Harbor's new research vessel, the *Sun Rocket*, completed a historic trip to Monterey waters last month.

For the first time in the sardine packing industry's history, a boat and planes were used simultaneously to scout for sardines far off the Central California coast. Fog and rough seas impeded the search, but much valuable information was obtained, according to JOHN DAY, Sun Rocket skipper.

The vessel kept in close radio contact with an amphibian plane privately chartered by the packers, and later with a Coast Guard plane that hunted for schools of fish in far as 100 miles offshore. The planes directed the Sun Rocket to scenes where schools were sighted.

Day said that there were excellent indications of fish existing in substantial quantities deep in the water 35 miles due west of Santa Cruz, where the sea was alive with bird life. Onset of the Southern California sardine season with large early runs caused Monterey vessels to hurry south, and an intensive follow-up on the research expedition had to be postponed.

JACK CRIVELLO, Sun Harbor president, was aboard the Sun Rocket on the trips both north to Monterey and back home. The vessel proved its seaworthiness in stormy weather, and to improve its performance still further, she was placed in drydock at Lynch Shipbuilding Co. to extend the propeller shaft and change the propeller size.

TOPS SALES
(Continued from Page 1)

since the guarantee was inaugurated July 1.

Latest triumph of the "Sun Harbor" brand is in order by the Navy Commissaire here for several hundred cases. The order was placed through Kimber-Wangenheim after Navy tests showed that "Sun Harbor" is as fine a tuna in money can buy, and priced at competitive scales.

LIGHTER LOST

A Ronson cigarette lighter was lost last month in the Sun Harbor plant. The owner offers a reward for the return of this keepsake to the payroll office.

SUN HARBOR ADDS TWO MORE "YP" VESSELS

Increasing the number of former Navy "Yippee" boats which will serve in Sun Harbor's constantly growing fleet, two more of these sturdy 125-foot refrigerated vessels were acquired last month.

They are the YP-618 and the YP-637, which joined three others undergoing modification for use as tunaboats by early 1948.

The YP-618, with JULIO BALELO as skipper, is at Marineshaft Shipbuilding Co. here, while the YP-637, to be operated by MANUEL CHULLA, former captain and part owner of the *Miss America*, is at Lynch Shipbuilding Co.

Sun Harbor now has two more former Navy "Yippee" boats being readied for service in its fishing fleet. Most recently acquired are the YP-618, at top, and YP-637, below. Inset photo shows left to right, Tony Pombo, who will be managing owner, and his brother, Joe, a co-owner. Manuel Chula, well-known former captain of the Miss America, will be skipper and managing owner of the YP-637.

This Sun Harbor Cannery *Catch and Can* newsletter identifies the YPs that were reconverted back to tuna clippers. (Courtesy of the Tarantino family.)

Beginning in the mid-1950s, a large number of tuna boats became idle, and canneries either shut down or were operating on a part-time basis due to the competition of the international tuna market by South American (Peruvian and Ecuadoran) and Japanese interests. In 1955, the American Tunaboat Association (ATA) sought government intervention to impose a quota on Japanese tuna, claiming that Japan had taken over almost half of the American market. In this image, ATA members and their families gather along the harbor to protest competition from Japanese imports. (Courtesy of the Maritime Museum of San Diego.)

Back from a fishing trip, John, Vince, and Joe Tarantino pose with their mother, Carmela, and their cousin Fred Sorci in their backyard on India Street. Although fishing continued to be a family affair well after the war ended, the industry suffered a major decline in the 1970s and 1980s. (Courtesy of the Tarantino family.)

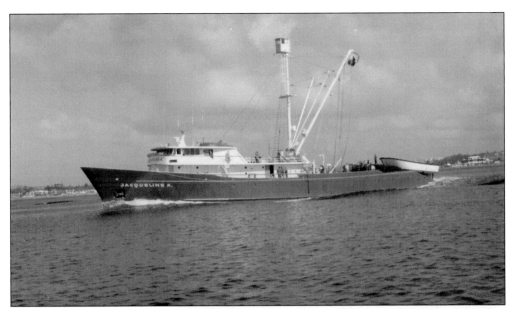

The *Jacqueline A* is one of the purse seiners built at NASSCO in the 1970s—one of three sister ships built. Capacity for a full load of tuna tripled in comparison to other seiners. Frank Balistreri was the navigator. (Courtesy of Rosemarie Balistreri, daughter of Frank and Angeline Balistsreri.)

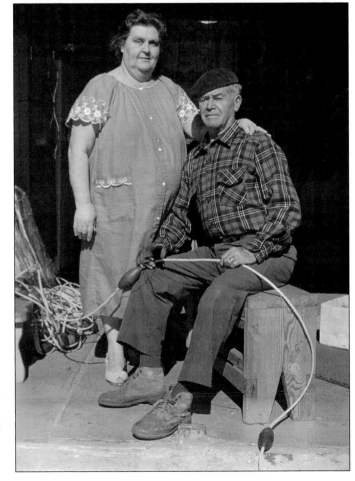

Giuseppe and Maria Carini are pictured at their home on Goldfinch Street in Mission Hills. Carini fished in Porticello, Sicily, before coming to San Diego in the 1950s to continue to fish with his sons. (Courtesy of the Carini family.)

Three generations of family members are pictured from left to right: John Canepa Jr., Jack Canepa, and John Canepa. The boat behind them is the *Mary Ann*, which was owned by Angelo Zolezzi, John Canepa's grandfather. (Courtesy of John Canepa.)

The story of John Mangiapane's boat, *La Vita*, is also indicative of the highs and lows of the fishing industry. Built locally in 1976, the *La Vita* was christened the following year. A mere 13 years later however, in 1989, ninety-foot swells off the coast of Cortez caused the boat to roll over. Although John Mangipane and his crew survived, they made local headline news, waiting hours in the water to be rescued. (Courtesy of John Mangiapane.)

The majority of tuna clippers were equipped with chapels. This particular chapel, in the shape of a boat's bow, is representative. In a terrible storm, a seasoned fisherman recalled crawling along the deck, finally making his way to the chapel for refuge and comfort, only to find that the chapel had been completely emptied of its prayer books and religious icons. He claims to have prayed in any case, huddled close to the fish in the holding tanks, awaiting rescue. (Courtesy of the Portuguese Historical Center.)

The bow of the modern steel purse seiner the *Uncle Louie*, built in 1978, is juxtaposed against the arch of the Coronado Bridge behind. Large purse seiners are far less frequent in San Diego Bay today, having given way to smaller and lighter pole-and-troll and gill-net fishing vessels. (Courtesy of Mr. and Mrs. Louis Castagnola and sons.)

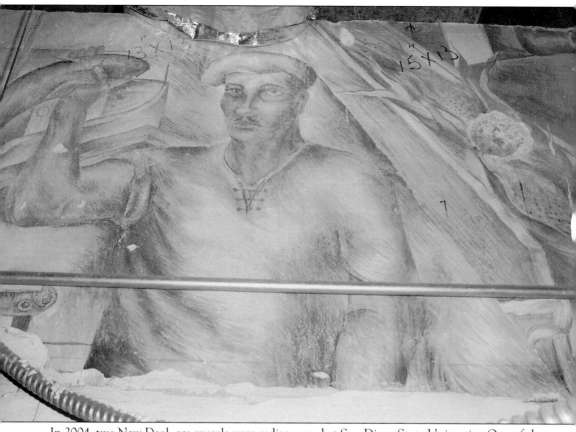

In 2004, two New Deal–era murals were rediscovered at San Diego State University. One of the murals, painted in 1936 by George Sorenson, is titled *San Diego Industry* and depicts various phases of the fishing industry in San Diego, including fishermen, cannery workers, and merchants. This section of the mural captures a fisherman with a beret. (Courtesy of Seth Mallios.)

Sorenson's mural similarly portrays the ethnic diversity of San Diego's fishing industry. In this panel, Chinese cannery workers sort the cans into large carrying cages. (Courtesy of Seth Mallios.)

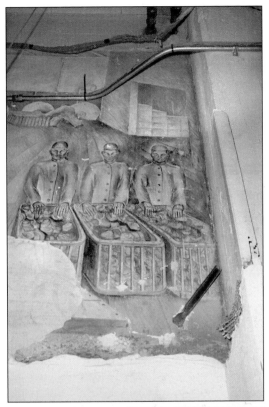

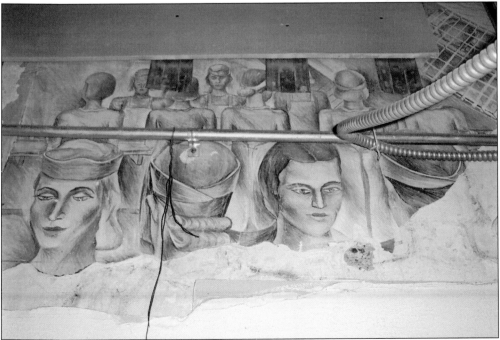

In this section of Sorenson's mural, women of various ethnic backgrounds are shown working the assembly lines in the San Diego canneries. (Courtesy of Seth Mallios.)

DISCOVER THOUSANDS OF LOCAL HISTORY BOOKS FEATURING MILLIONS OF VINTAGE IMAGES

Arcadia Publishing, the leading local history publisher in the United States, is committed to making history accessible and meaningful through publishing books that celebrate and preserve the heritage of America's people and places.

Find more books like this at
www.arcadiapublishing.com

Search for your hometown history, your old stomping grounds, and even your favorite sports team.

Consistent with our mission to preserve history on a local level, this book was printed in South Carolina on American-made paper and manufactured entirely in the United States. Products carrying the accredited Forest Stewardship Council (FSC) label are printed on 100 percent FSC-certified paper.

MADE IN THE USA